5/₂

Use this space to attach your own Dear Photograph

Dear Photograph,

HarperCollins books may be purchased for educational, business, or sales promotional use. For information please write: Special Markets Department, HarperCollins Publishers, 10 East 53rd Street, New York, NY 10022.

FIRST EDITION

Library of Congress Cataloging-in-Publication Data has been applied for.

ISBN 978-0-06-213169-0

12 13 14 15 16 RRD 10 9 8 7 6 5 4 3 2 1

Dear Photograph

TAYLOR JONES

WILLIAM MORROW

An Imprint of HarperCollins*Publishers*

Dedicated to the memory of Mr. Ianni . . .

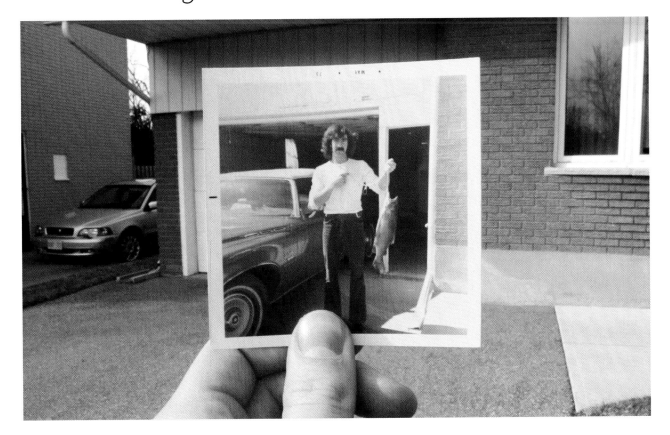

Dear Photograph,
Dad, you built the roof over our heads and the love in our hearts. We miss you.
Love, the Ianni family

and Mrs. B.

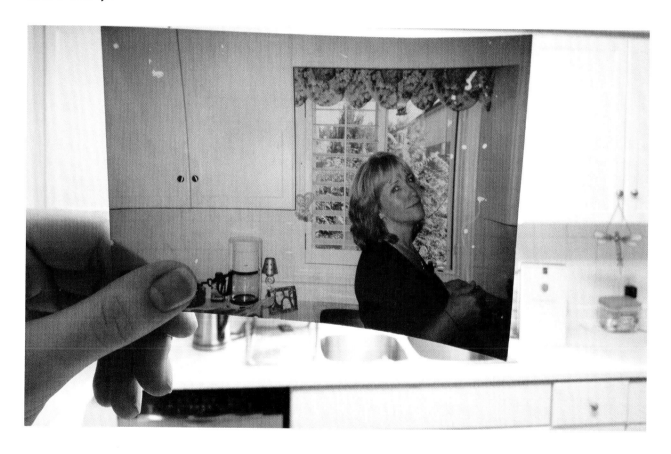

Dear Photograph,
Without you in our lives, we would not have found the strength to be where we are today.
The Blasman family

THE BEGINNING

My life changed completely on May 25, 2011. I was twenty-one years old and living with my parents in Kitchener, Ontario, Canada. For all the times I'd thought of moving out on my own, I'm so thankful that I hadn't yet flown the coop. Again that night it was proven that everything good in my life has always started at home. We were just finishing up one of my favorite meals—homemade ribs and rice à la Mom, which I've come to crave and appreciate all the more since moving out—and we decided to look through an old photo album together. We didn't have to go digging through half a dozen dusty boxes hidden away in the attic—nope, not in the Joneses' house. Mom, an avid scrapbooker, had piled our house high with hundreds of albums, which she had carefully filled with thousands and thousands of family photos. Our lives had been beautifully and thoroughly scrapbooked.

Keaton, my youngest brother, grabbed a blue photo album, the kind with plastic sheets inside to keep the photos protected. The album was from 1995 or so, and it featured photos of my younger self and family, back when fanny packs and big glasses were the fashionable items of the day and my wardrobe was incomplete without suspenders and OshKosh B'gosh overalls. We gathered around the kitchen table and began to look through the album.

As Keaton turned the pages, I noticed a photo of a three-year-old Landon—my middle brother—beaming beside his Winnie the Pooh birthday cake. When I looked closer, I realized that Landon had been sitting at the exact same table we were sitting at now, in the exact same chair. And when Mom had taken that old photo, she'd

been sitting where I currently sat. I grabbed the photo from the plastic and held it up in front of me, matching the old photo of Landon against the present scene. It really is true: when the light goes on in your brain, everything seems to slow down and become very quiet, almost soundless. Everyone at the table—Mom, Dad, Landon, Keaton, and even my dog, Mylie—gave me quite the looks. Dad asked, "What in the world are you doing?" Little did we know that this odd moment would start a worldwide viral phenomenon.

I began running around the house with various old photos in hand, taking picture after picture, holding up each shot against its present location and snapping a new photo to capture the scene. The light bulb came on again, and I knew I had to share these photos with my friends. I sat down at my computer and decided to upload the photos to a Tumblr blog. When I uploaded Landon's winning grin and beloved cake, Tumblr asked for a caption. I wondered: What would Landon say to his picture if he could talk to it? I typed out a salutation: "Dear Photograph." And then I thought, Landon has this swagger thing going on, a little bit of attitude and edginess mixed together with brotherly love. I finished the caption: "Dear Photograph, I wish I had as much swag then as I do now." I showed it to Landon, and he loved it. I posted it to my blog, along with five other photos. Every caption expressed my desire to reconnect in some way with my past, and every photo took me back in time, letting me relive each memory for one short moment.

My friends loved the photos and shared them with other people, who in turn did the same. I then created a Dear Photograph Twitter feed and Facebook page. The number of hits seemed to grow exponentially day by day, and people from all over the world started submitting their beautiful photos and personal stories. The response astounded me. It was mind-blowing to go from sixteen hits to one hundred to three thousand, and suddenly I was looking at a quarter of a million hits from Reddit, a social media site. After the news site Mashable picked up Dear Photograph, my idea began to create unbelievable buzz in media outlets worldwide. The experience was so surreal—after all, I was Taylor Jones, the kid who was always coming up with crazy ideas that never amounted to much, and finally I'd created something that had value and meaning and a life of its own. I realized that Dear Photograph had truly struck a chord with people, no matter who they were or where they came from. People simply wanted to relive a moment, on their own or with someone special. These nostalgic moments seemed to warm a lot of hearts . . . including my own.

As you turn these pages, it's my sincere hope that you enjoy the Dear Photograph experience and share your fellow neighbors' desires and wishes. If this book inspires you to search for those pictures of days gone by and revisit the places of your past, then I'll have achieved my goal. Find that one special photo and make your own Dear Photograph to add to the empty page left just for you in this book. In the meantime, put up your feet and take some time to reflect upon the people, places, and memories that hold deep meaning for you. I hope Dear Photograph will help you remember that time with friends and family is precious and fleeting. Suddenly, like the flash of the camera . . . you aren't here anymore.

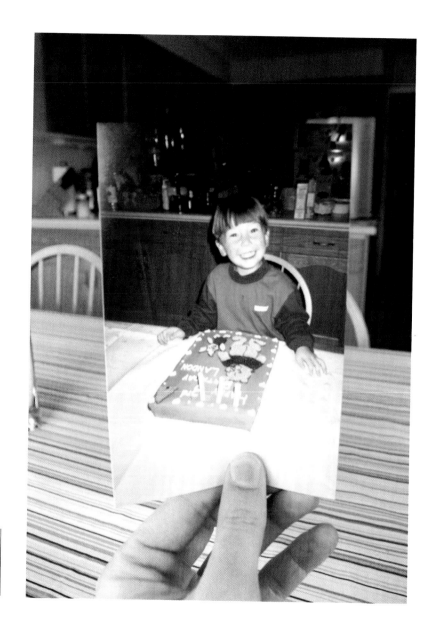

Dear Photograph,
I wish I had as much swag
now as I did then.
Landon Jones

How to Take a Great Dear Photograph

1. Select a photo from the past that means something to you.
2. Visit the site of the original photograph, and hold up the old photo in front of your camera.
3. Get in the right position: align the photograph with the real-life scene.
4. Make sure to get your hand in the picture. It shows that you stood at the original spot where the old photo was taken.
5. Check carefully to make sure the real-life background matches the edges of the photo from the past. Don't worry if the old photo isn't square with the new photo when you're lining them up. It's more important to have a great match with the present background.
6. Hold still . . .
7. Take the shot! (And take some extras so you have a few to choose from.)
8. Write a caption that addresses the photograph. You might write about the subject or the setting of the photo, or you might express a desire to revisit the moment. It's important to speak to what the photograph means to you.
9. Submit your cherished memory to **www.DearPhotograph.com**.

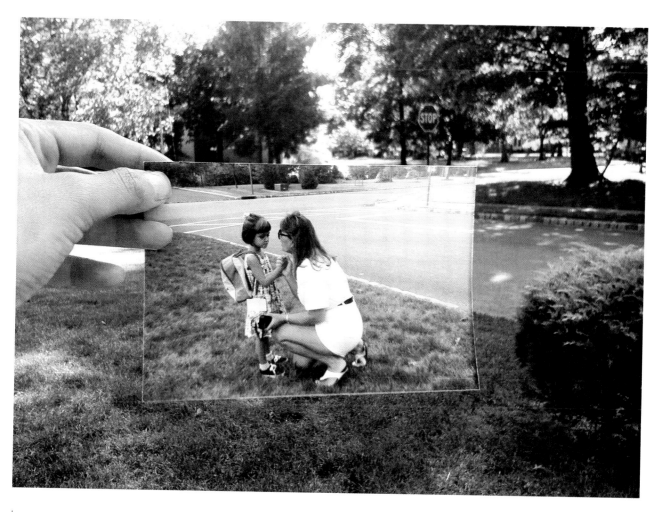

Dear Photograph,
Letting go of my mother's hand on the first day
of school was always the hardest.
Liz

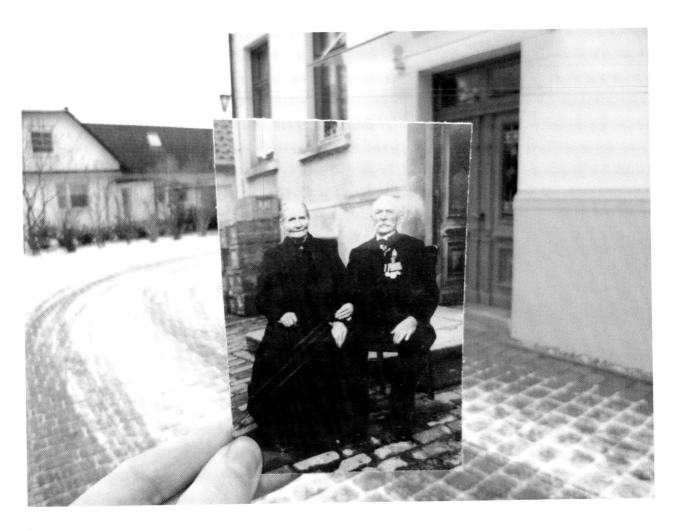

Dear Photograph,
I know you are my ancestors, sitting there in front of the house I grew up in, where my family still lives today. Even though we have lived in different times and a generation or more apart, I somehow feel closely connected to you both. Gitte

Dear Photograph,

Thirty years ago, I was that little boy who could see the beauty in all things far and wide. Perhaps that is the innocence of childhood . . . looking at life with clarity and simplicity, always enjoying the view.

I hope I never lose sight of that. Giuseppe

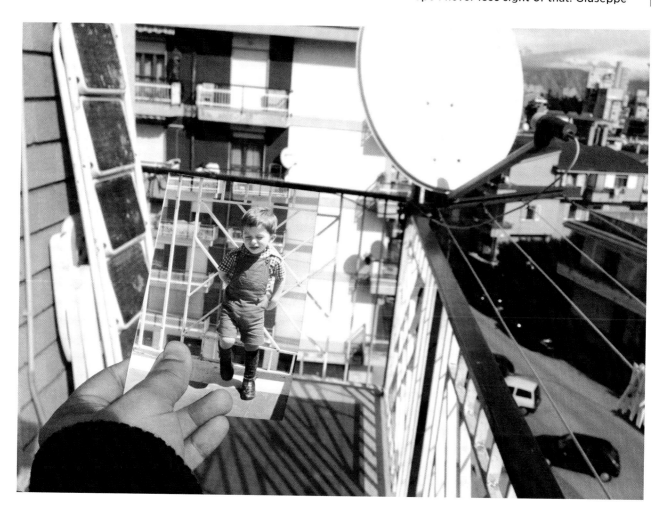

Dear Photograph,
Grandma still lives there, but she's all by herself now.
Ryan

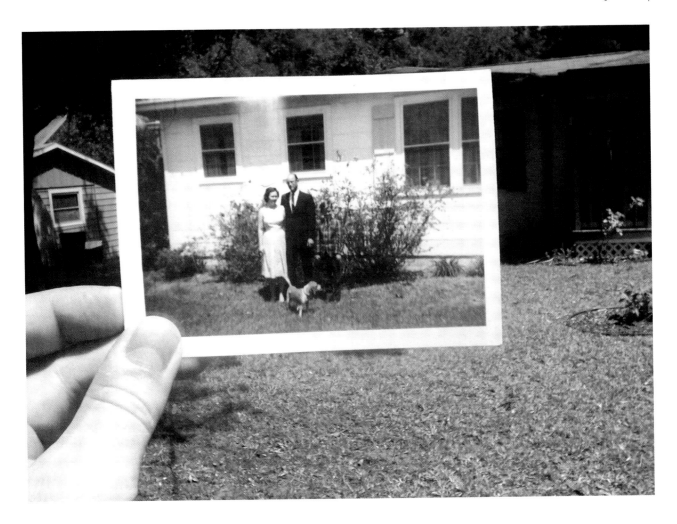

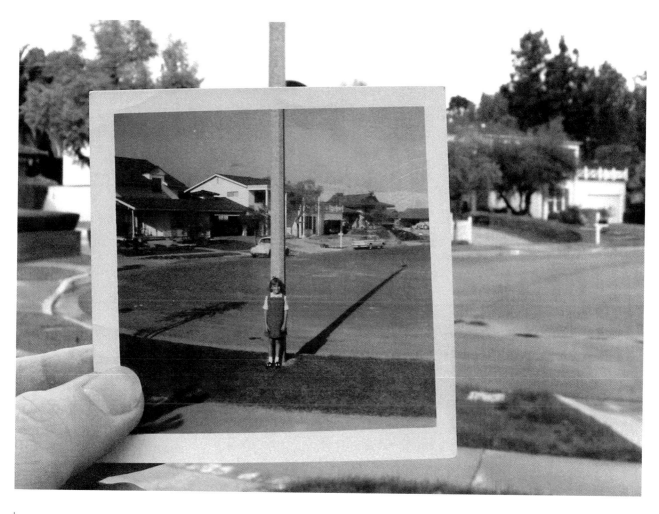

Dear Photograph,

Remember when you had to come home when the streetlight came on? Where are the good old days when the neighborhood was full of kids outside playing tag, hide-and-seek, and Wiffle ball? Those were kick-the-can fun times! Linda

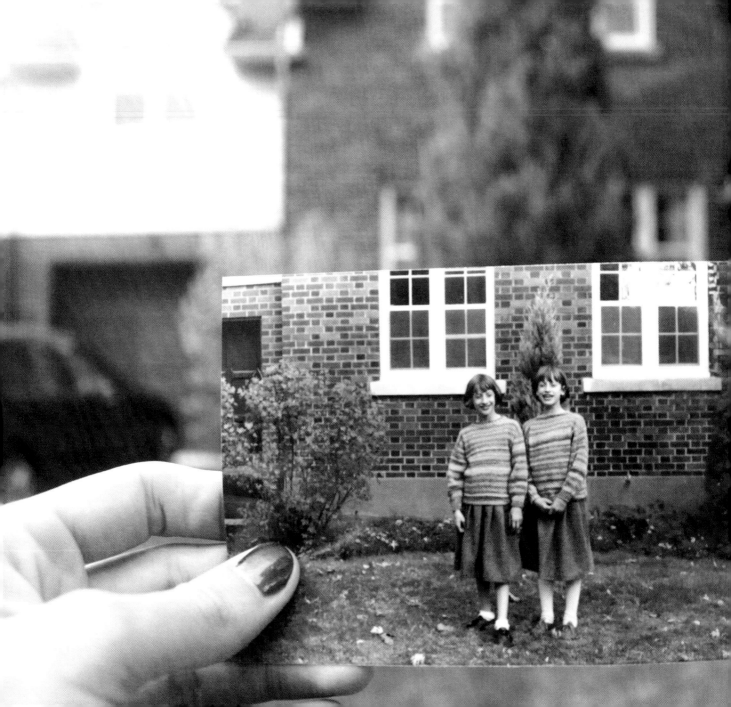

Dear Photograph,
I miss the days when we dressed the same;
I miss everything about you. I wish I was
better at telling you that when I see you.
Love you, Twinny

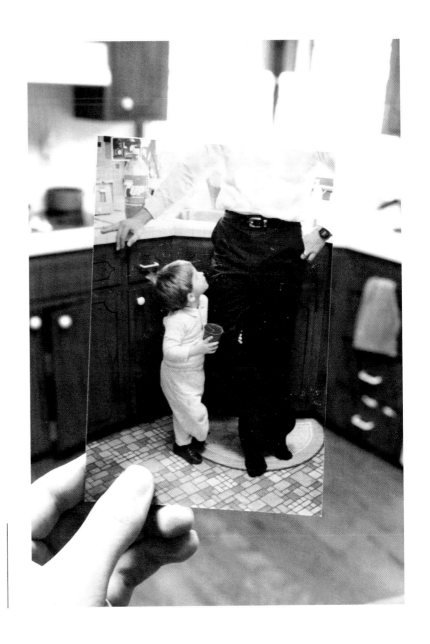

Dear Photograph,
I've always looked up to you and
I always will. Love you, Dad.
Ben

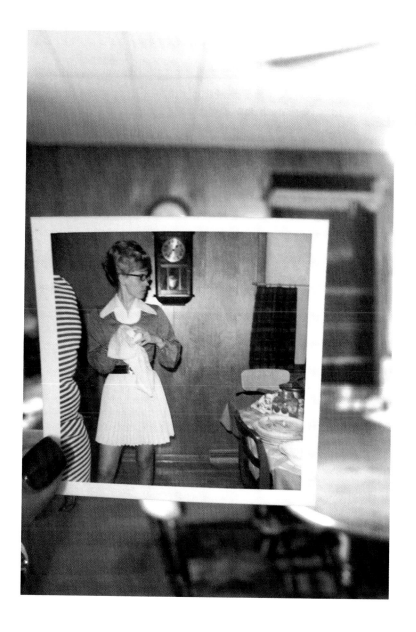

Dear Photograph,
She's still the most beautiful woman
in the world to me.
Love, Janelle

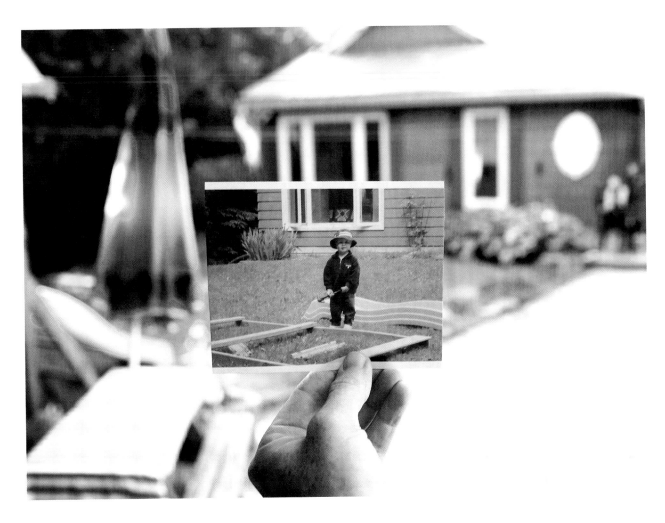

Dear Photograph,
It doesn't matter how old you get—you'll always be my little helper.
Holly

Dear Photograph,
My sister wishes she still had that car. That makes two of us!
John

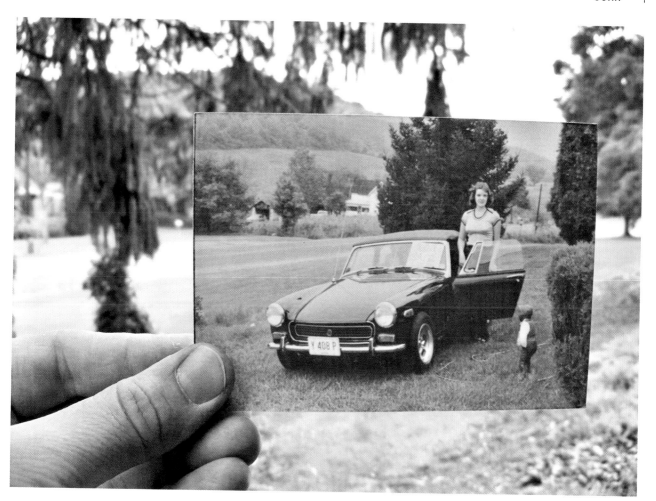

Dear Photograph,
Sunday walks and Mom dressing
us all the same. Twenty-nine years
later, it doesn't seem so silly after
all. Maybe we should do it again.
Michel

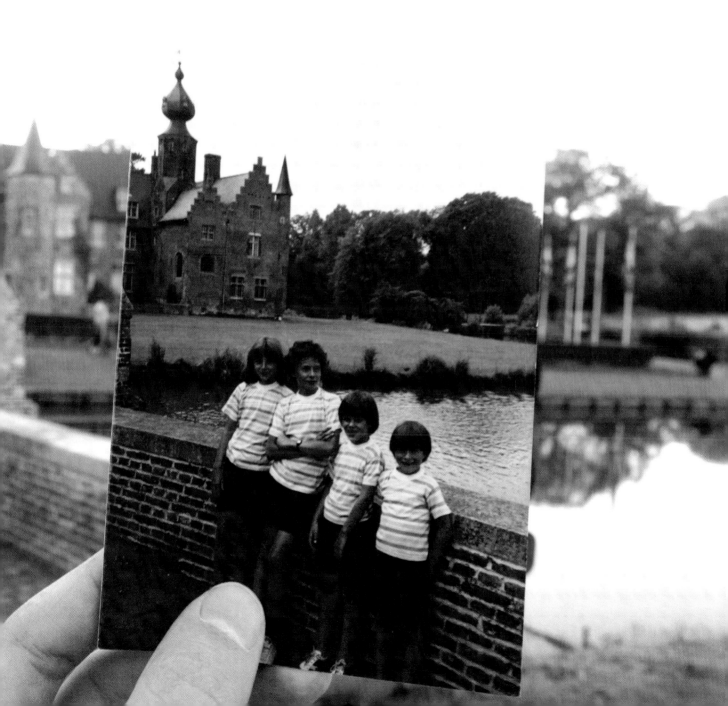

Dear Photograph,
Looking back at my mom at age
nine, I can see even then that she
was a confident young woman. She
still stands tall and proud today,
even taller, in my eyes. Thank you,
Mom, for teaching me to be strong.
Love, Nicole

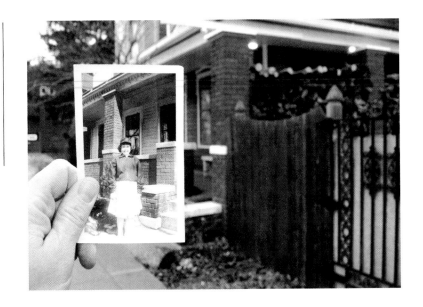

Dear Photograph,
Her family built our house in 1911.
I wonder if she knows how much
love and laughter have filled
these walls. May it stand strong
for another hundred years.
Deanna

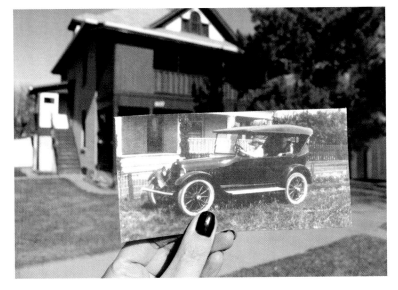

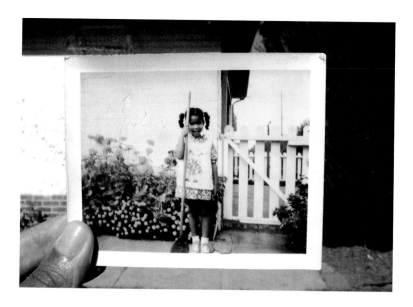

Dear Photograph,
I'm so grateful that my mom was handpicked by God for me, just like the flowers at her childhood home. She's perfect and lovely and loved.
Love, Shaunie

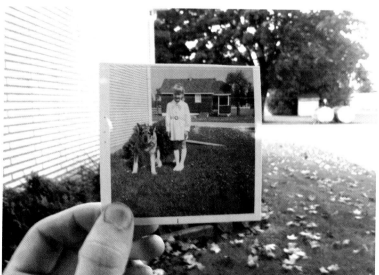

Dear Photograph,
That little girl has always loved her canine companions. Now I know where I get it from. Thanks, Mom.
Justin

Dear Photograph,
Grandpa loved the outdoors. But he loved us more.
Pam

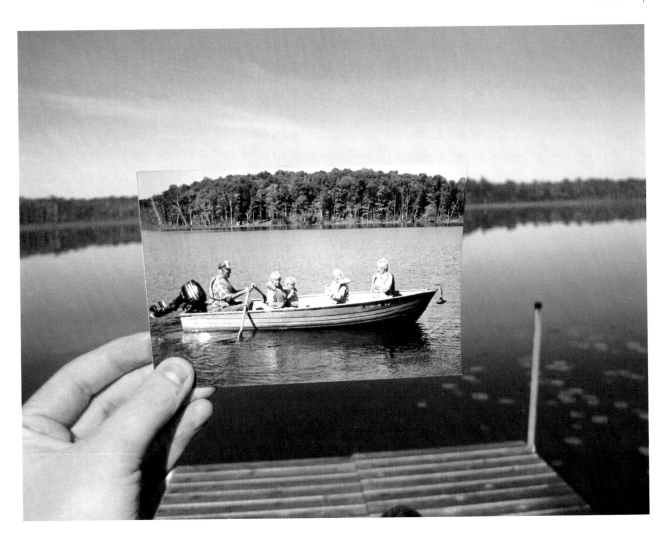

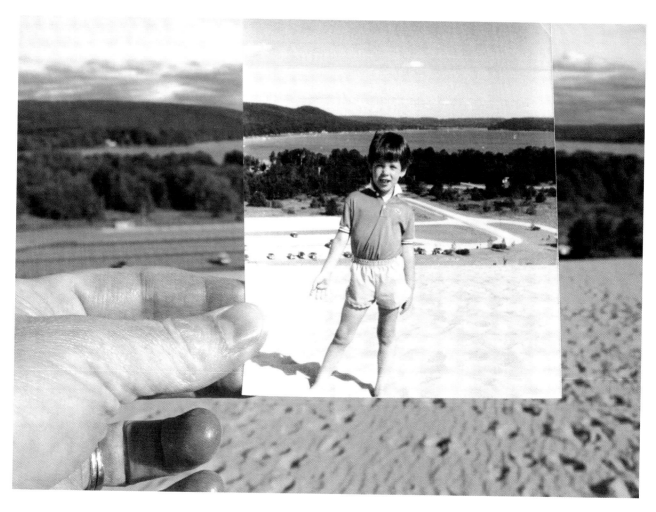

Dear Photograph,
Every year the question was, and always will be,
did you beat Mom and Dad up the dune?
Love, Bob

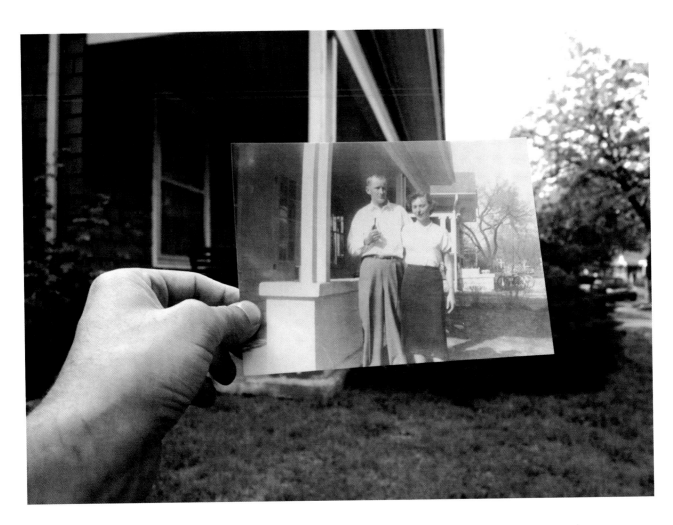

Dear Photograph,
I found you in the attic when we moved in. I wonder
if they lived happily ever after here.
Alex

My parents, newlyweds forty years ago, opened this gate to build a legacy of love. Dad built the house, and within those walls it held all of our precious family memories. Those happy times will never be for sale.

Fermec

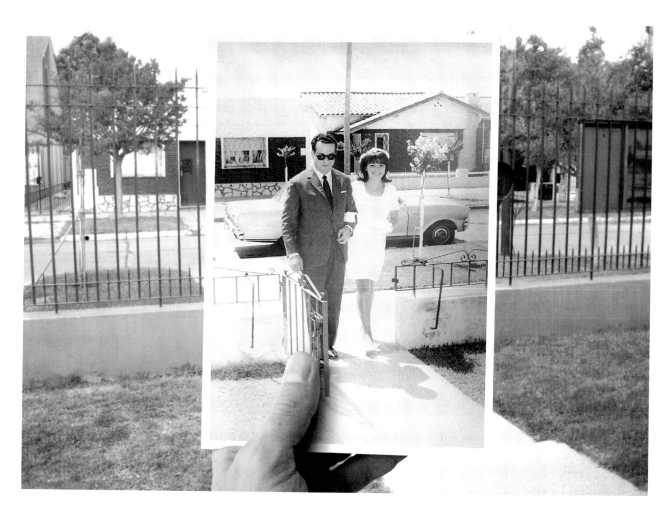

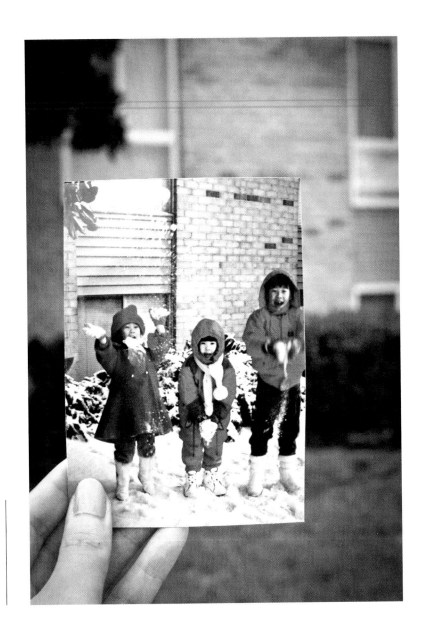

Dear Photograph,
Twenty winters may have come and
gone, but my brother and I still feel
that same rush of joy whenever we
hear the words "snow day"!
Angela

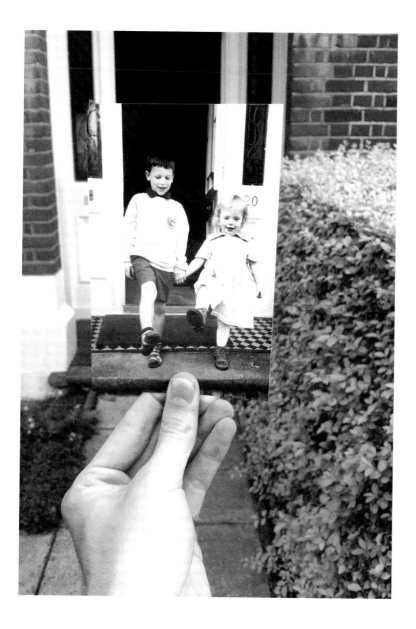

Dear Photograph,
Why did you let her lead you
up the garden path?
George

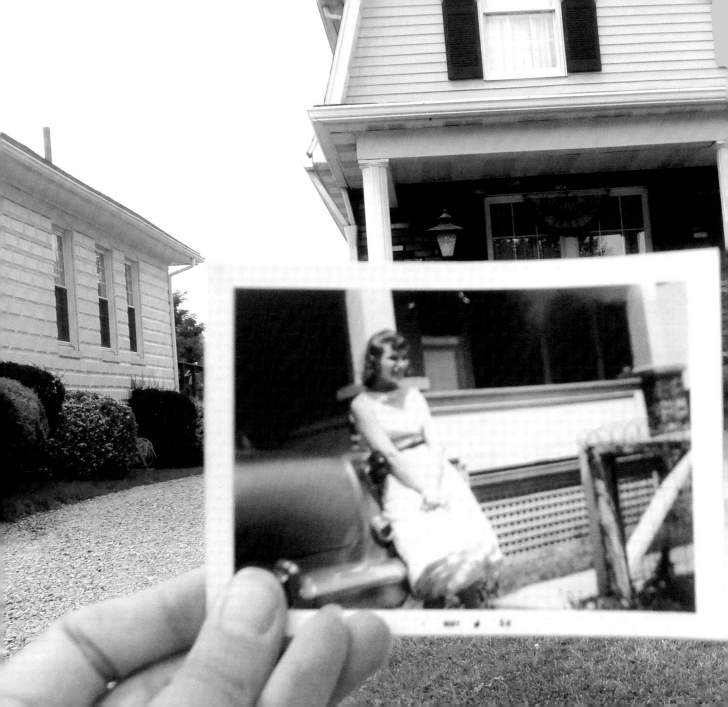

Dear Photograph,
If I could talk to you now . . .
Linda

29

Dear Photograph,
I can't take Grandpa with me wherever I go anymore,
but his joy in life's journey follows me still.
Love, Sandy

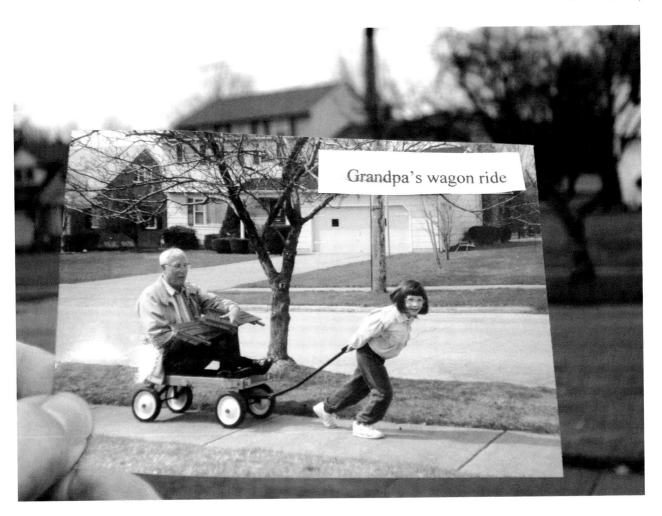

Grandpa's wagon ride

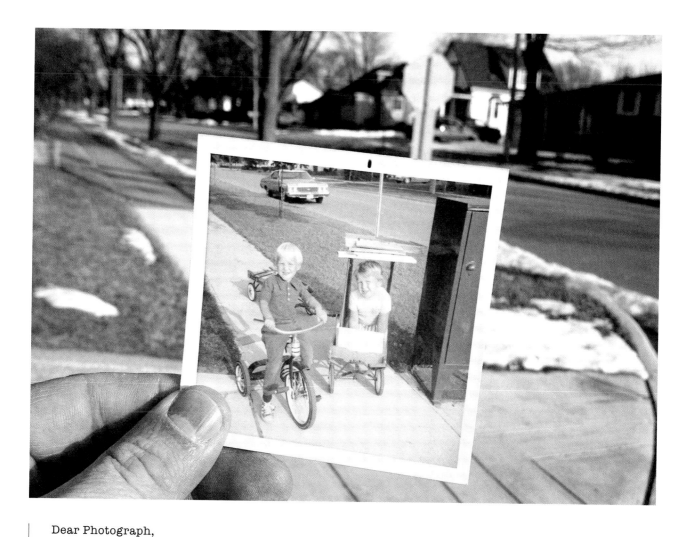

Dear Photograph,
Be kinder to your brother, because you need each other. Thirty-eight years later,
you will still be the best of friends when all the others fade away.
Darin

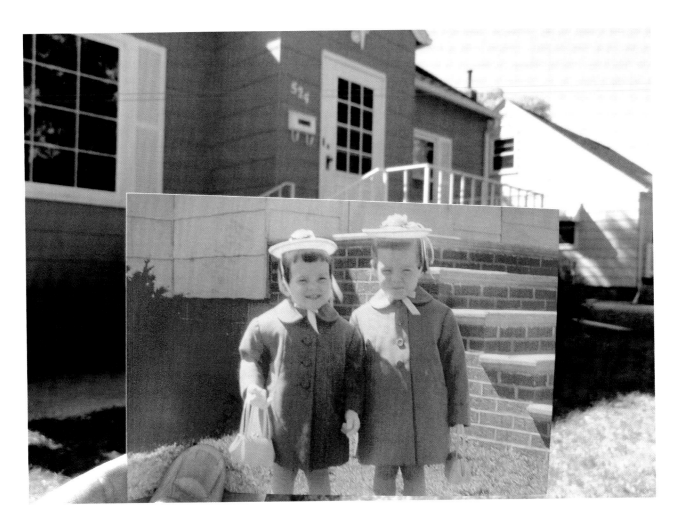

Dear Photograph,
I always felt braver with my older sister beside me, but especially
when we were wearing our paper-plate Easter bonnets!
Barb

Dear Photograph,
I loved to hear the happy sound of my
son coming home from school.
David

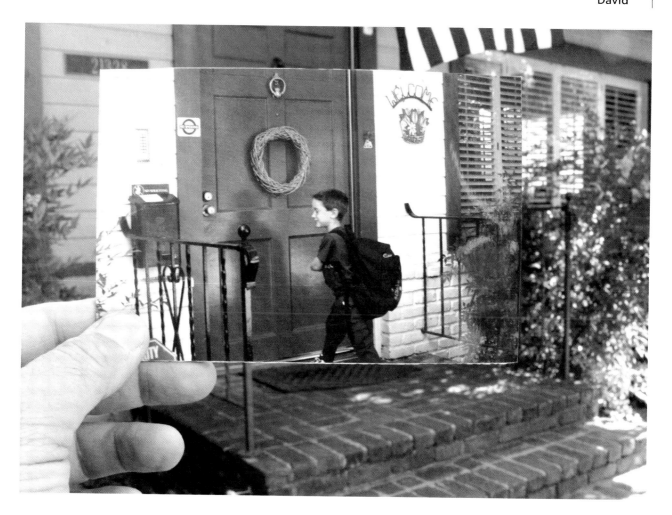

Dear Photograph,
Twenty-five years later, the church is still standing and so are my parents' vows.
Kyler

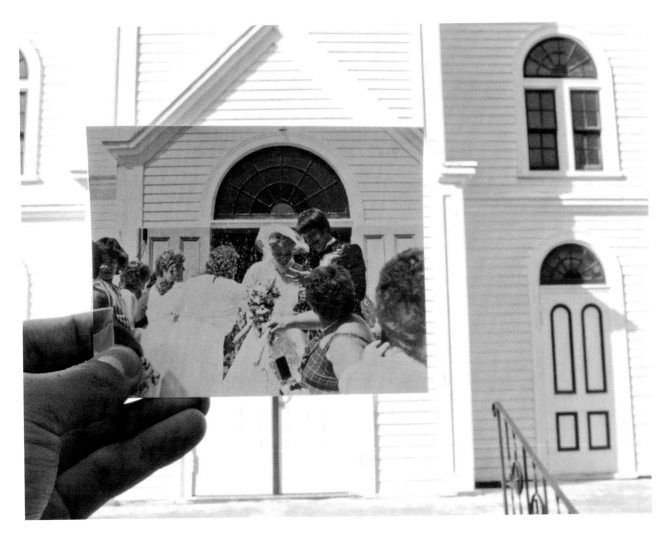

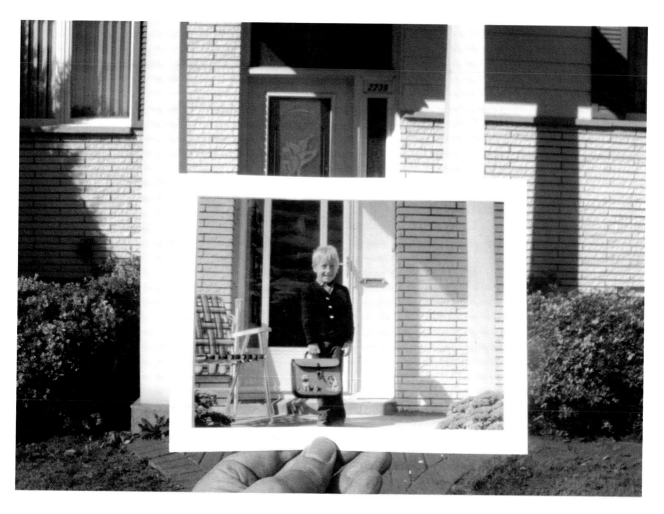

Dear Photograph,
Stepping out in style my first day of school, I sure held on tight to my favorite briefcase. I thought everyone would want one just like it!
Yves

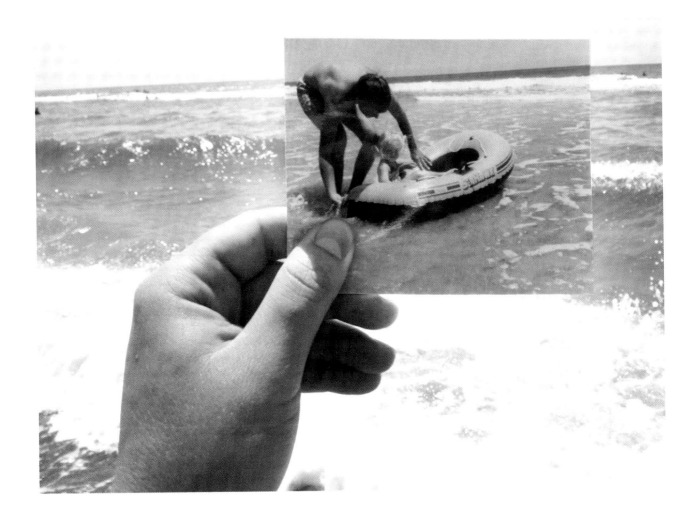

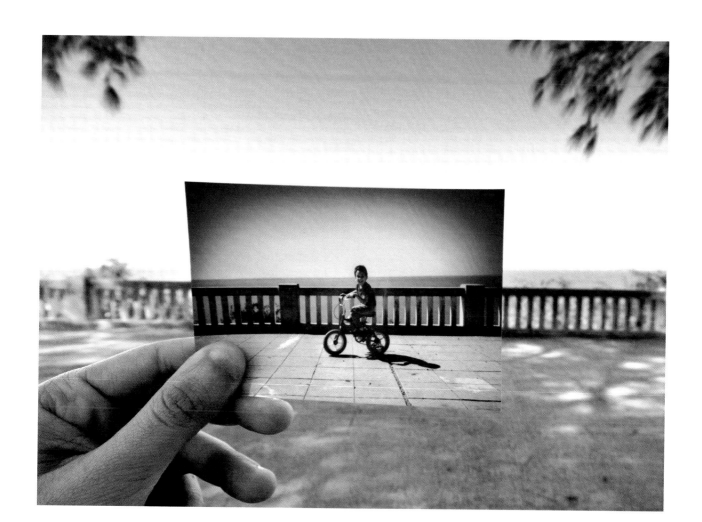

Dear Photograph,
You're the only memory I have left of this.
Luis

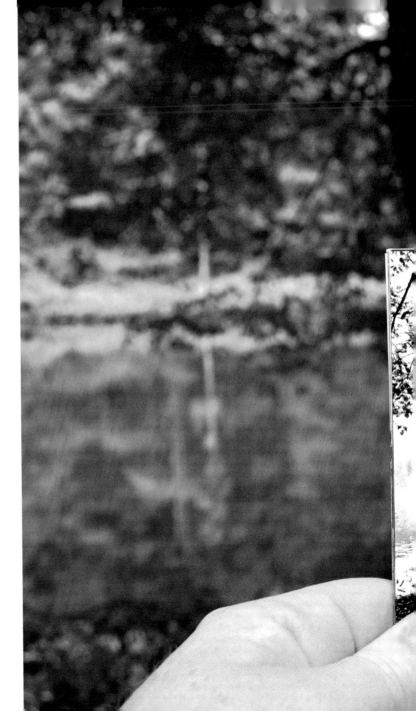

Dear Photograph,
I fell in love with a woman. I'm not
ready to let go . . . but she is.
McKenzie

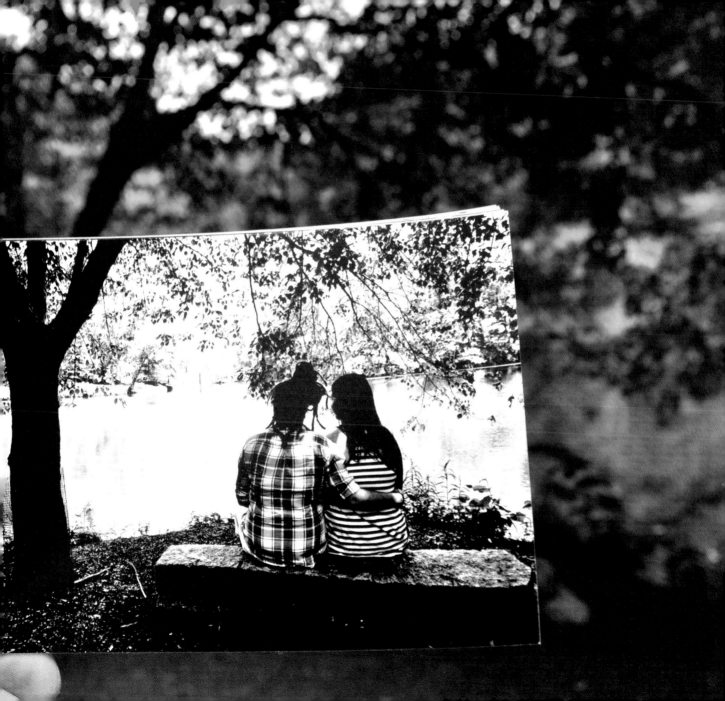

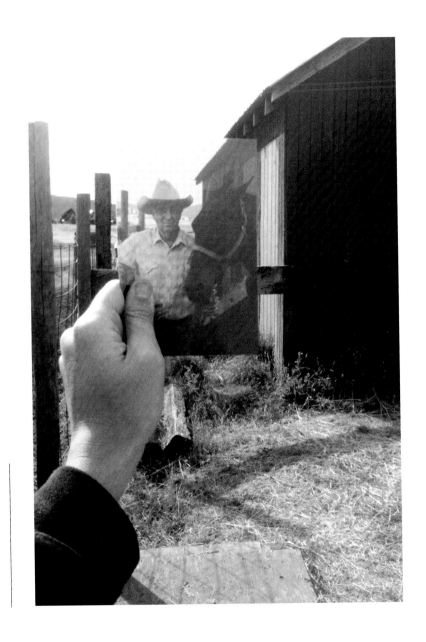

Dear Photograph,
You were a real cowboy right down to
the wallet you carried in your boots and
the way you rode horses and roped cattle
throughout your battle with cancer. How
we wish you didn't have to ride off into
the sunset. Missing you forever.
Love, your family

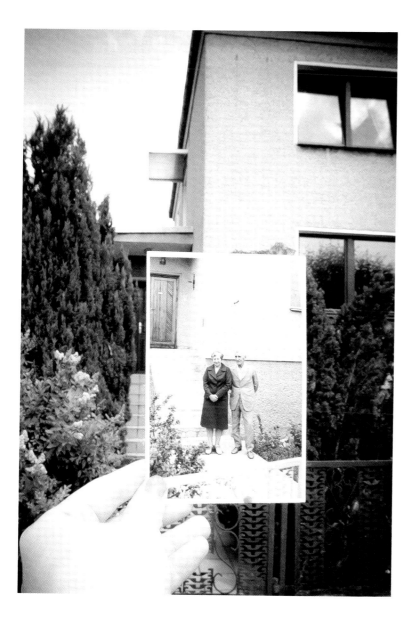

Dear Photograph,
They built this house with
their bare hands.
Malwa

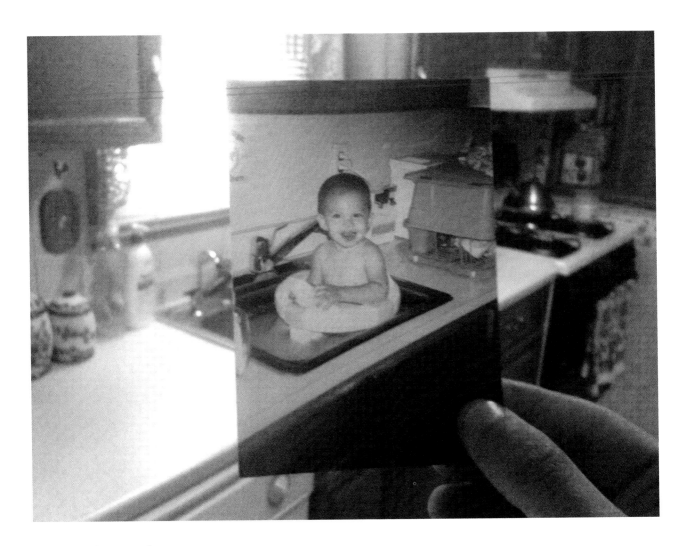

Dear Photograph,
Once upon a time I fit in the kitchen sink.
John

Dear Photograph,
I used to love to run from the falling mattress before it would squash me.
If only that were still the worst of my worries!
Jono

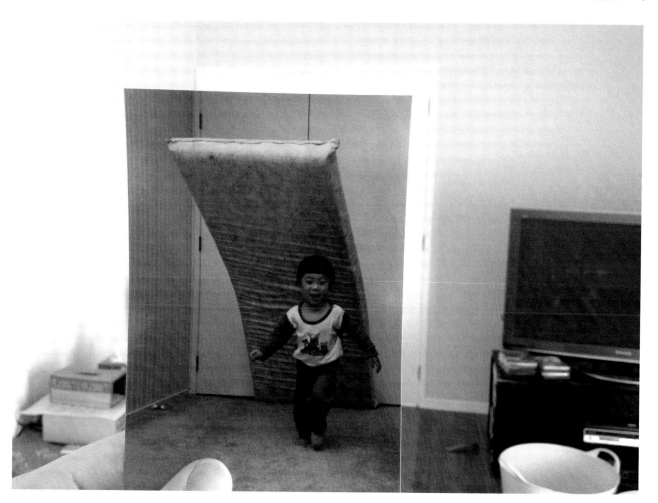

Dear Photograph,

I love that my husband's childhood home was rich in history, and it's where we hang our hats today. It's like putting on an old comfy pair of slippers when you walk through the door to the memory from years gone by of his mom's freshly baked cookies. It means everything to me to carry that love forward. Beth

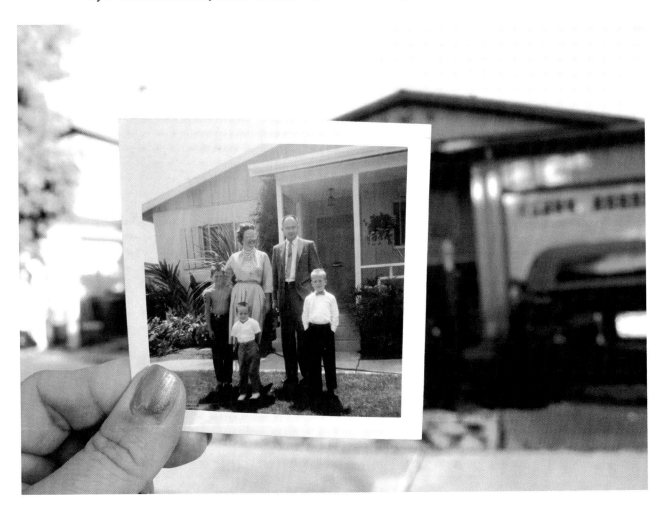

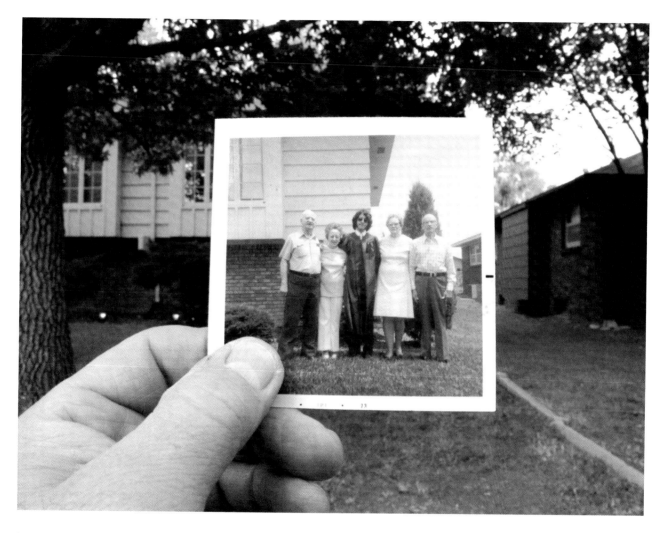

Dear Photograph,
High school graduation in 1973, and my shades are now back in style.
Pat

Dear Photograph,

It all started with a tee in the backyard. Fast-forward twenty years, and he's successfully taken his love of the game all the way to the college mound.

A baseball mom

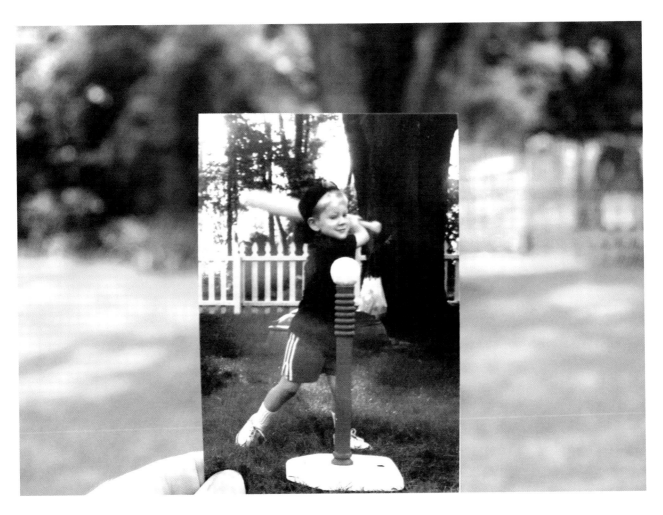

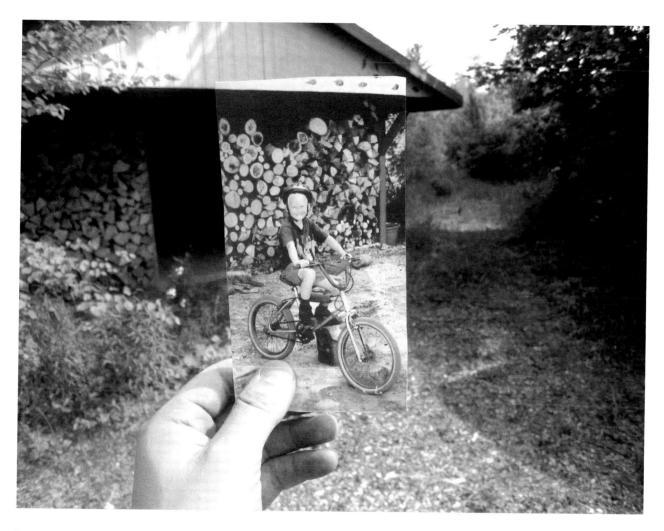

Dear Photograph,
Sometimes I still feel like my feet can't touch the ground.
Adam

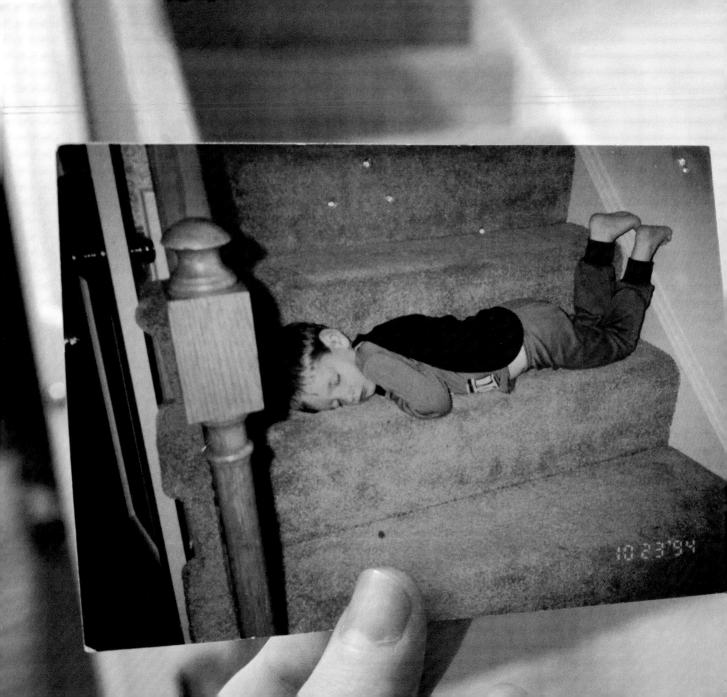

Dear Photograph,
Seventeen years ago, sneaking down
the stairs after being put to bed was the
ultimate adventure. I should put my cape
back on while I still have time.
Mark

49

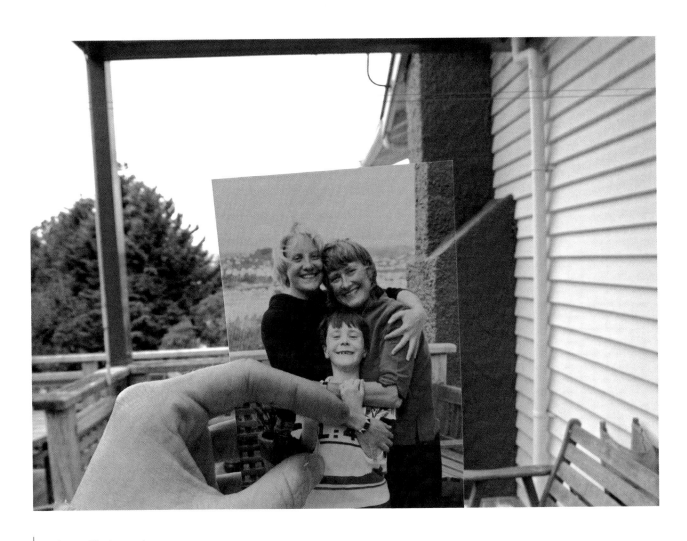

Dear Photograph,
I miss our family group hugs.
Alexander

Dear Photograph,
The end of that road seemed like such an adventure!
Sophia

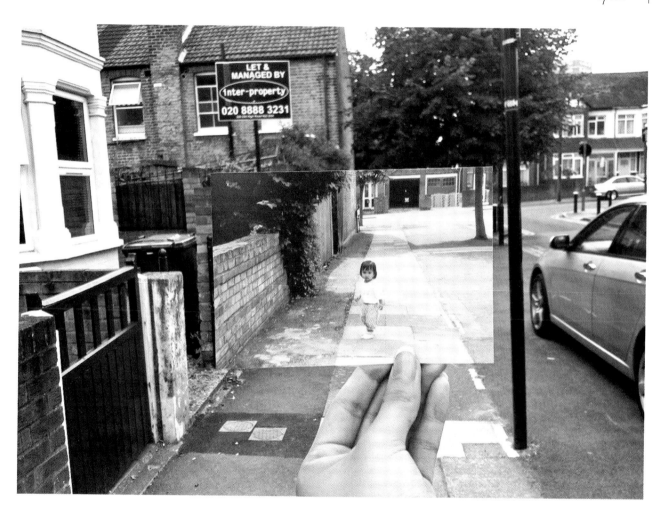

Dear Photograph,
Endless blue skies, summer days at the cottage, and my grandfather fishing with his son. It was a time to remember.
Julia

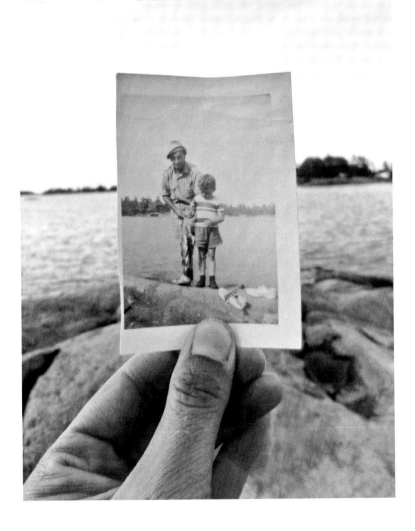

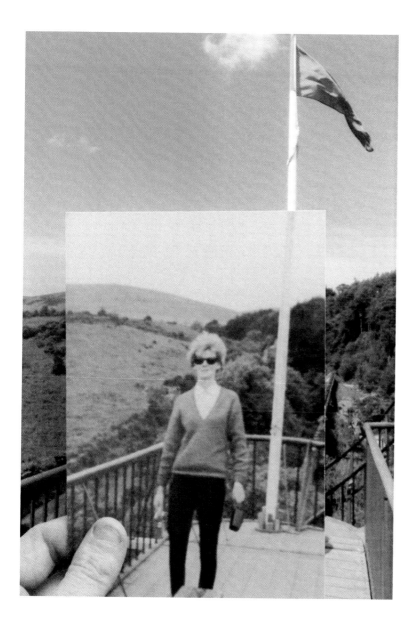

Dear Photograph,
I hope you can see me now, Mum.
Love, Julie

Dear Photograph,
Love was in the air when my grandparents came to honeymoon
in Brighton. Fifty-four years later, their love is here to stay.
Love, Rachel

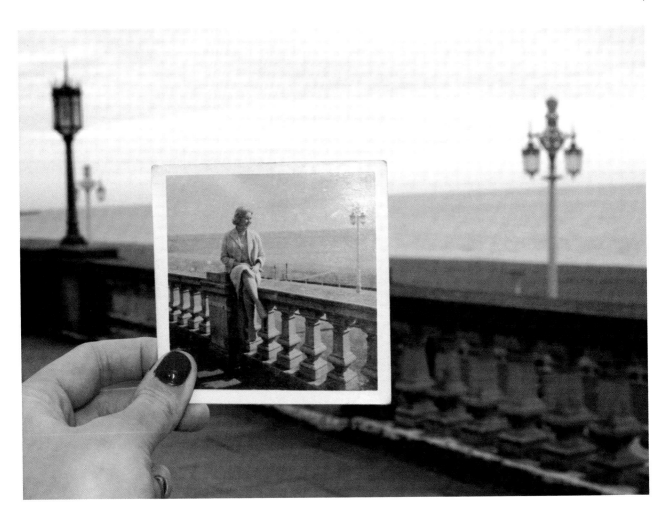

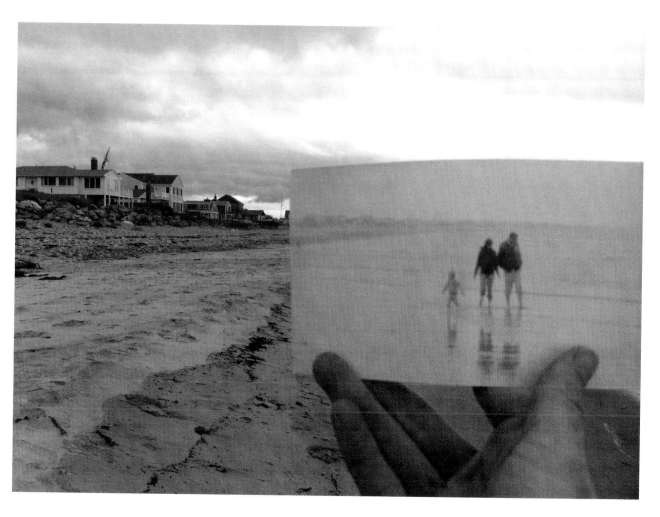

Dear Photograph,
I'm thankful for every rainy walk on the beach that I ever
had with my grandpa. Lucky for me, there were lots and lots.
Alanna

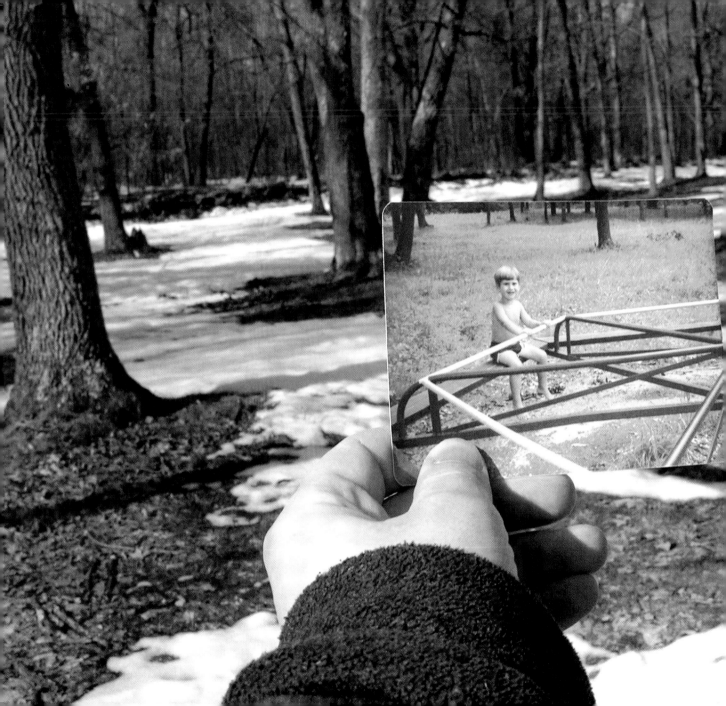

Dear Photograph,
Thanks for reminding me that when my
life is going in circles I can always get off
and go in another direction.
B.J.

Dear Photograph,
Her view won't be the same without the trees.
Jen

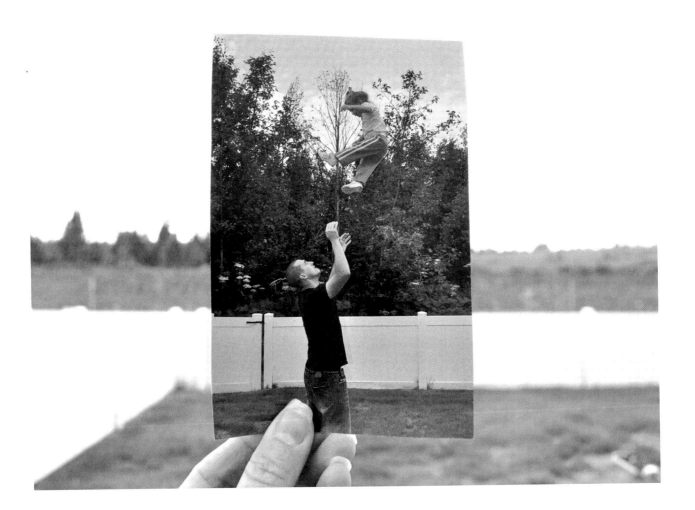

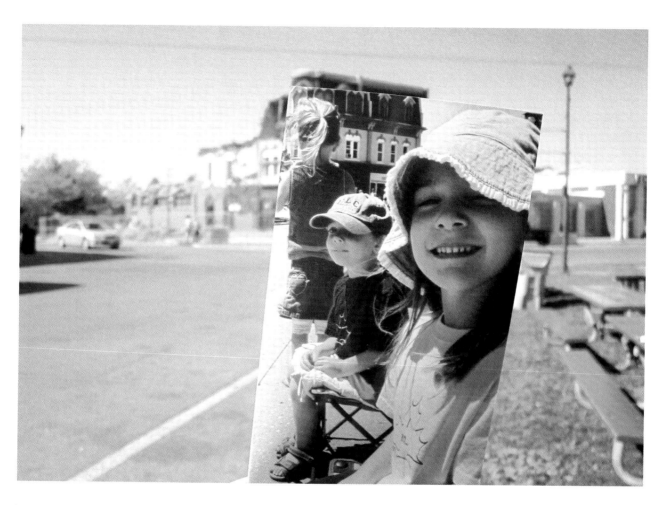

Dear Photograph,

With the winds of a tornado, Goderich, Ontario, changed more in a few seconds on August 21, 2011, than it had in all the decades previously. We're slowly shifting to more smiles than tears on the Square again. It will take time to heal. Much love to my dear hometown, Jacki

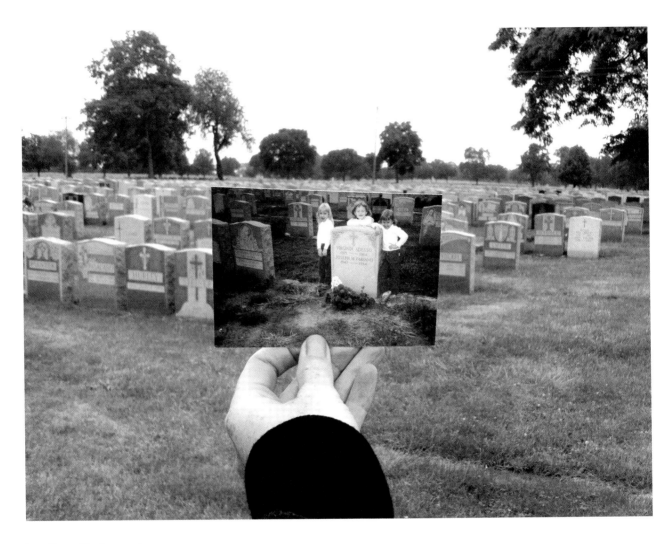

Dear Photograph,
We outgrew the clothes, but never the visits with you, Daddy.
Kimberly

Dear Photograph,
When was the last time my brother and I dropped everything
to get knee-deep in coal and think of nothing else?
Adam

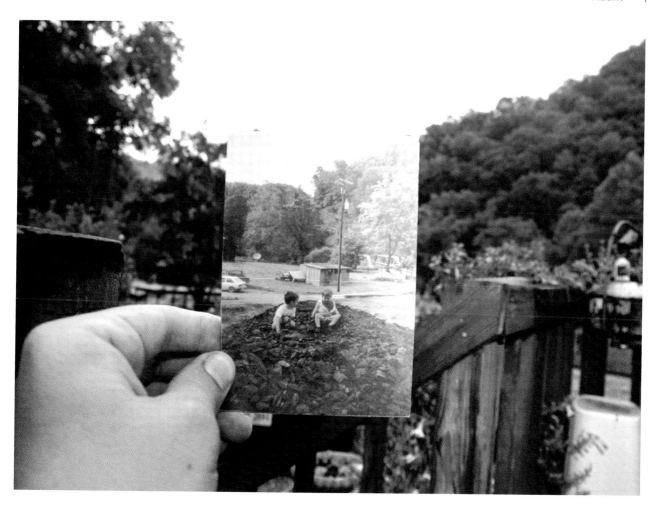

Dear Photograph,
I miss the days when you were here to watch over us.
But don't worry, Opa; I'm still here watering your flowers.
Love, Marisa

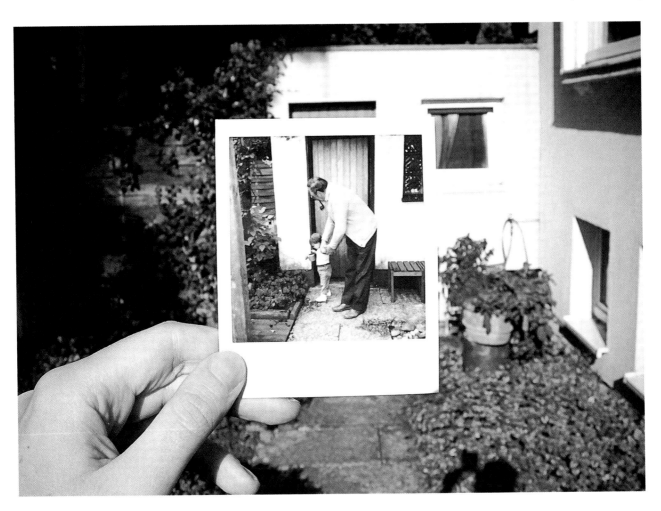

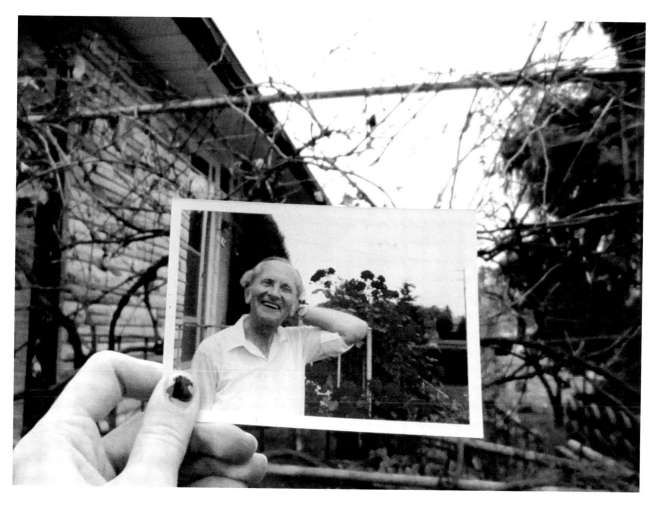

Dear Photograph,
Now that he's gone, I can hear his wisdom whispering to me
among the thorns in my life. My grandpa taught me so much.
Love, Jessica

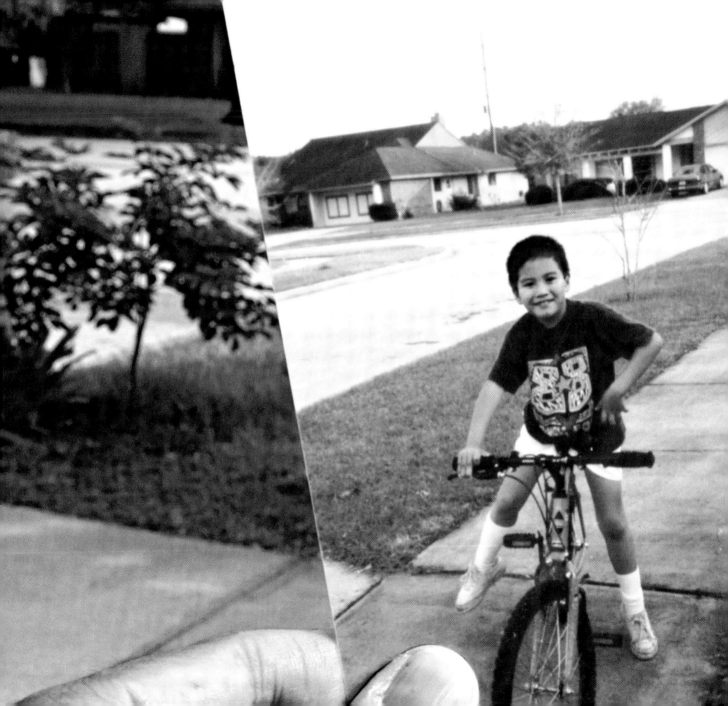

Dear Photograph,
You remind me of all the good times with my little brother, like when he rode his bike all around the cul-de-sac. We will forever miss seeing Roberto and his smile as he came up the driveway to our house.
Love, your big brother, Oliver

Dear Photograph,
My mum wanted to have one more
summer to just sit by the pool, but
cancer took her away before the season
changed. I'd give anything to relive this
moment with her by my side.
Aidan

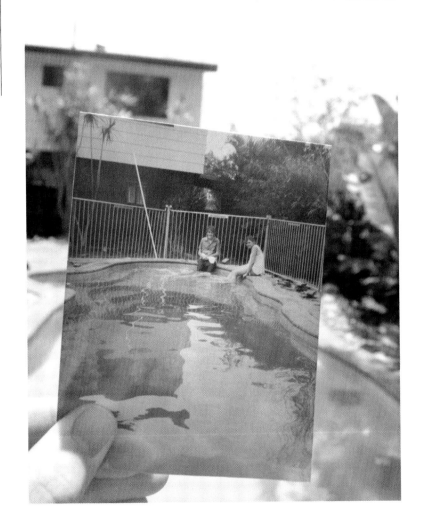

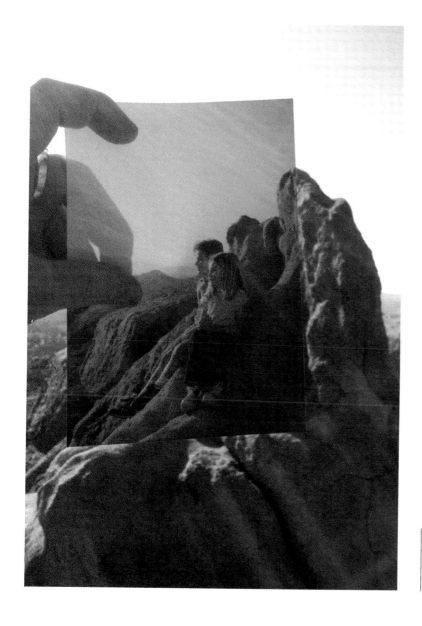

Dear Photograph,
You kids are my rock.
Love, Dad

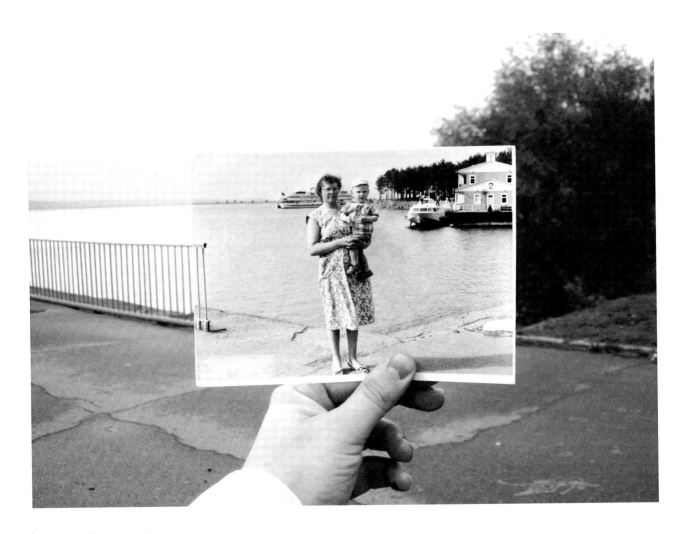

Dear Photograph,
One thing is certain—I know I can never be held in Mother's arms
quite like that again.
Aleksey

Dear Photograph,
We couldn't wait to get suited and baseball booted, ready
to board the train to *Elvis the Musical* at the Astoria.
Jeffrey

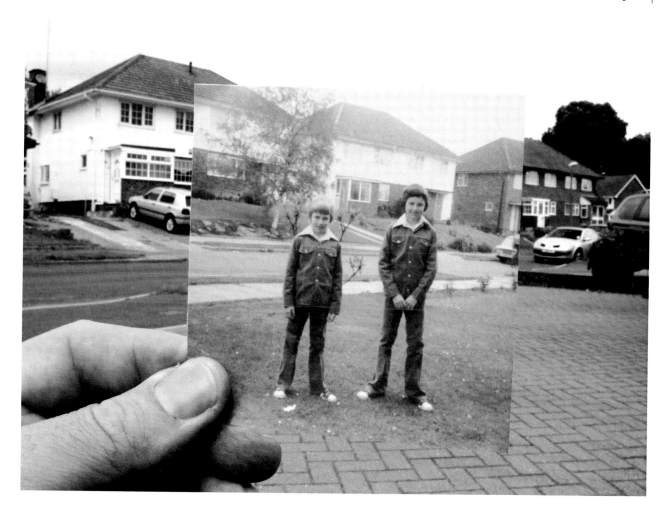

Dear Photograph,

Sometimes you have to just sit and enjoy the view from your own backyard.

I hope my little one will do the same.

Amy

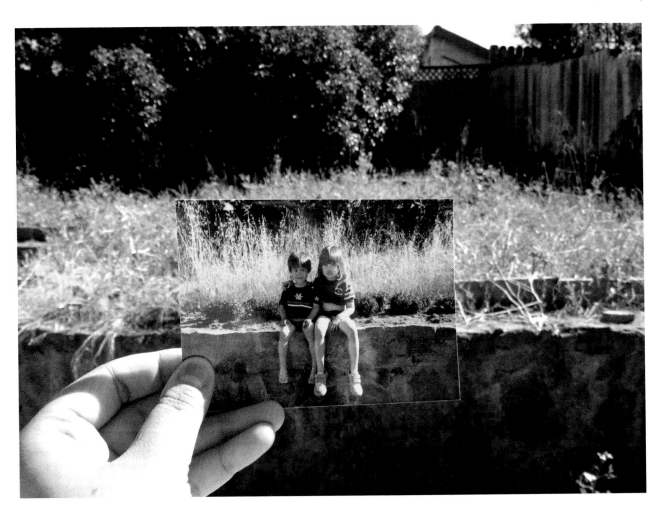

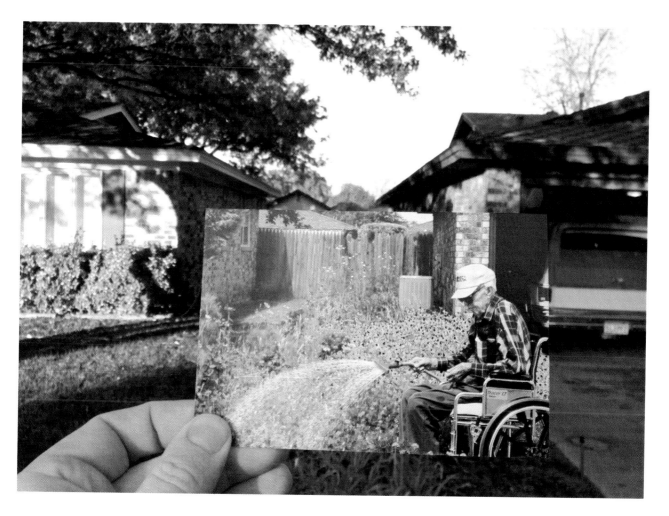

Dear Photograph,

Nothing ever stood in the way of my grandfather and his flowers.

He was a farmer till the very end.

John

Dear Photograph,
Kissing on the dock of the bay . . .
Our love is here to stay.
Love, Camillia

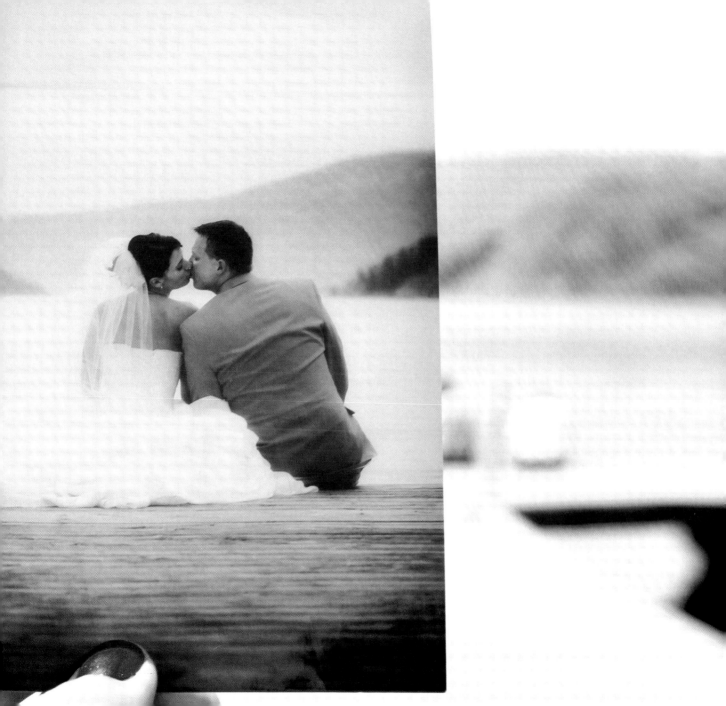

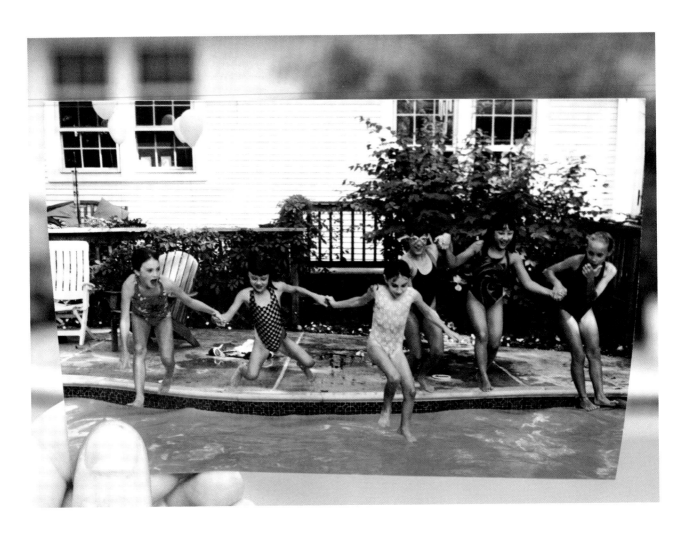

Dear Photograph,
I remember summers of chlorine hair and soaking the patio with
gut-busting laughter.
Claire

Dear Photograph,
Thank you for reminding me that neither time nor distance
can break the bonds we share. I just love these girls!
Andrea

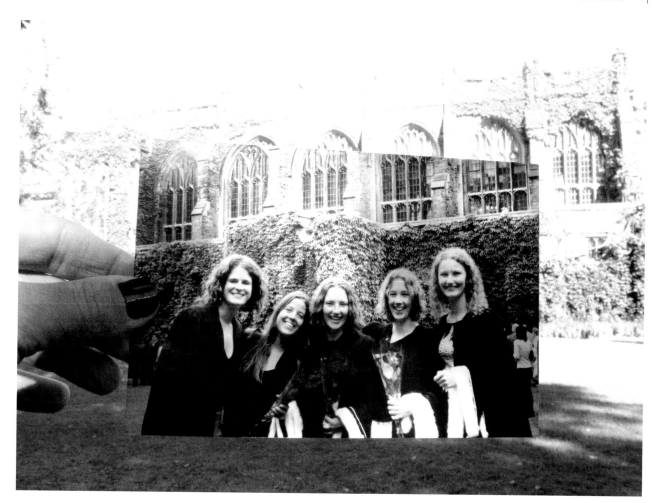

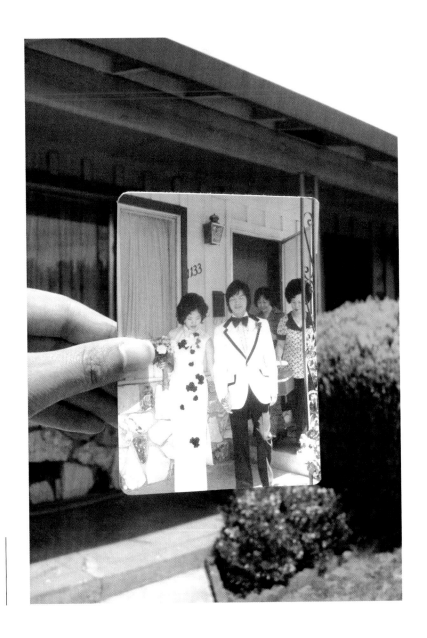

Dear Photograph,
My mom still has her wedding dress.
I can't wait to wear it one day.
Winnie

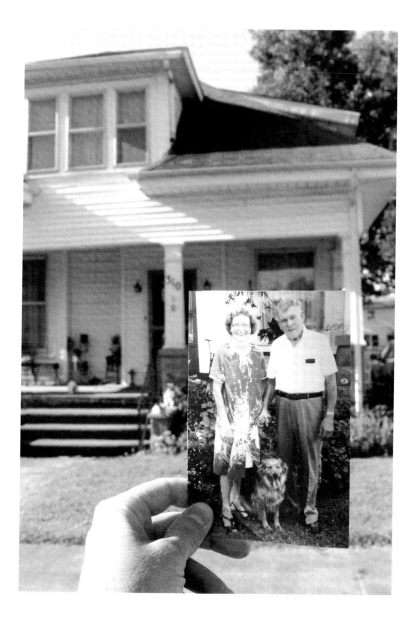

Dear Photograph,
The house still looks the same,
the flowers are still beautiful,
but now Grandma waves
good-bye to me alone.
Love, Tamia

Dear Photograph,
Kids grow up, but patio furniture stays the same.
Eric

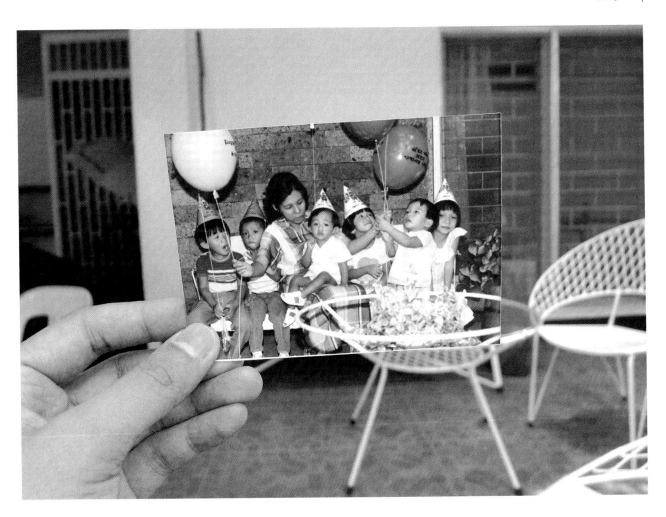

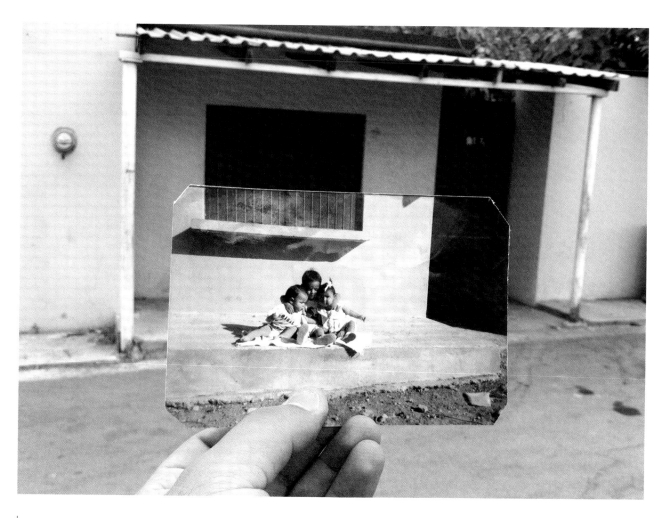

Dear Photograph,
That's love.
Mithical

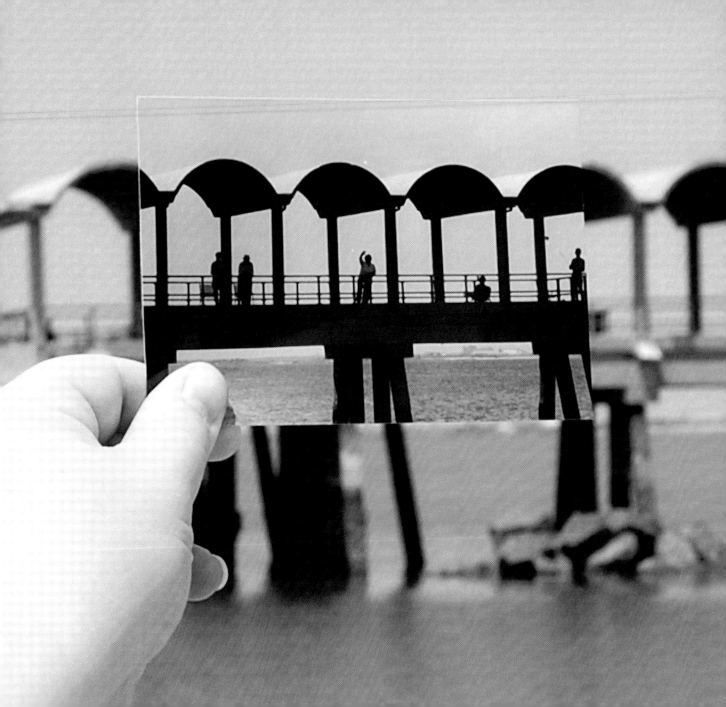

Dear Photograph,
I like to pretend she's still
in her favorite place, waving
to us from the pier.
Love, Beth

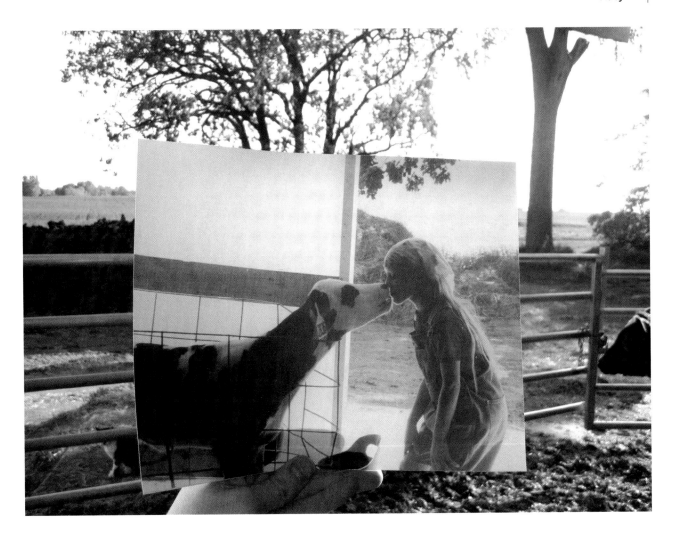

Dear Photograph,
I never would have guessed that I would miss hanging out in the sticks and
riding barefoot all day long. I sure took those days for granted.
Love, Maggy

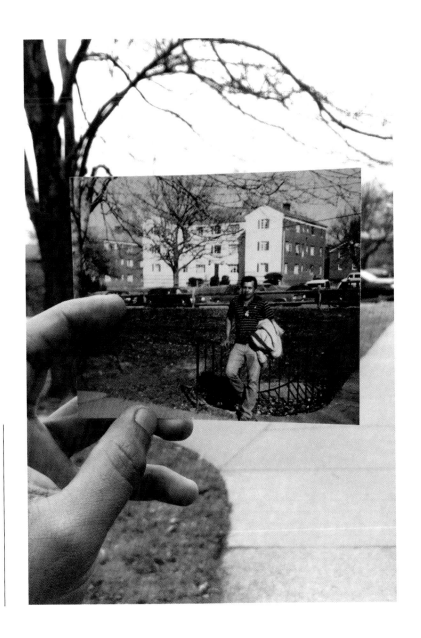

Dear Photograph,
Even though cancer took you away
from Mom, Jamie, and me, you still
permeate my every thought. I would
give up everything I have just to be
able to see you one more time, Dad.
I couldn't even tell you that I love
you but I'll say it now: I love you.
With my sadness and
tears, your son, Edgar

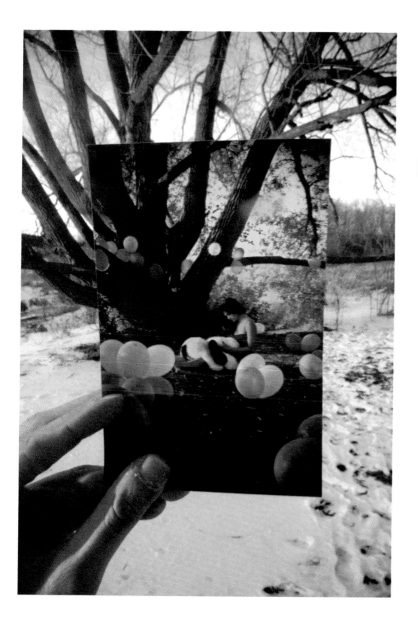

Dear Photograph,
I still remember every moment I
spent with you that summer. You always
thought we were just friends, but to me
you always meant so much more. A year
and a half later and you're my valentine.
Happy Valentine's Day!
Your boyfriend, Louis

Dear Photograph,
My mom was just sweet sixteen when JFK passed through Paterson, New Jersey, campaigning for president. She carried the photo in her wallet for years, long after he was assassinated.
Chris

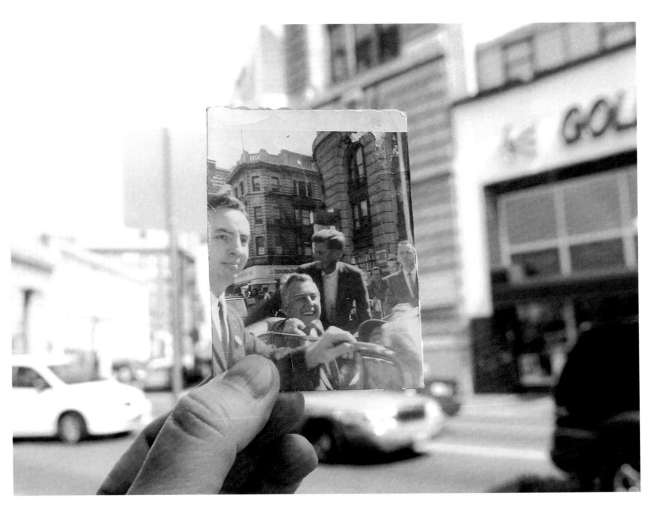

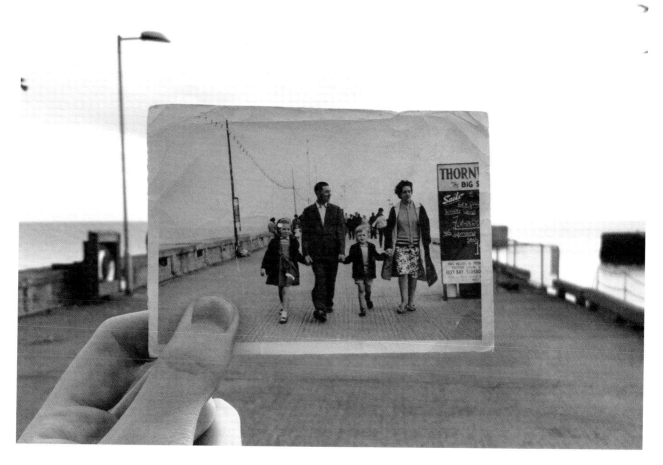

Dear Photograph,

Grandad Harry, the godfather of our family, was a successful, funny, extremely kind, and unbelievably generous man. He worked in the docks until he was drafted by the navy in World War Two. We celebrated his great love for the sea by scattering his ashes in Bridlington Harbour, right where he strolled long ago, hand in hand with his family. The beginning of his legacy. Miss you dearly, Daniel

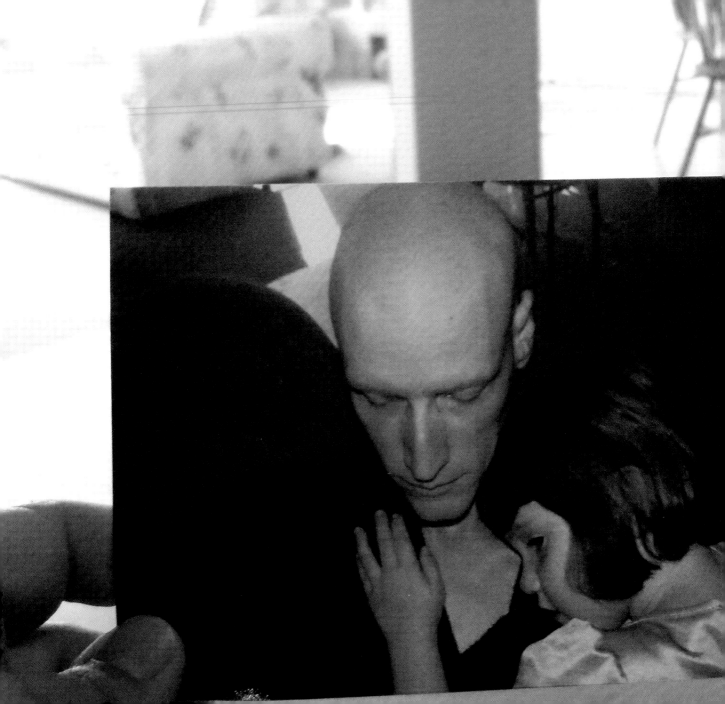

Dear Photograph,
Her love was my chemo. I beat cancer.
Eric

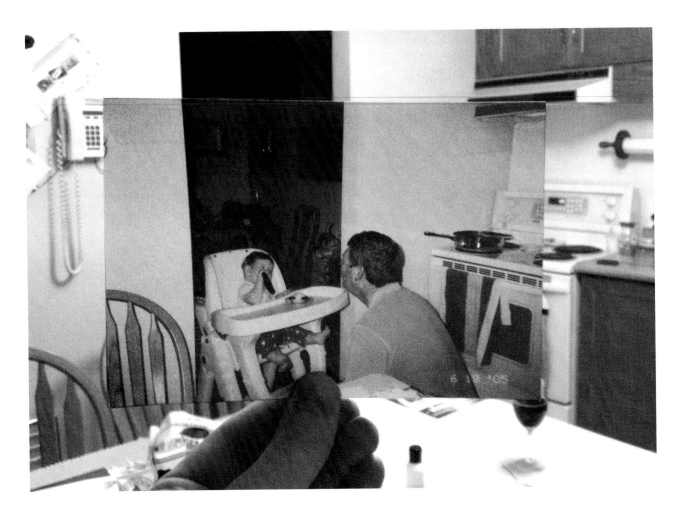

Dear Photograph,

My dad loved his family and granddaughter, and you didn't need to see his face to know it; you could always feel the warmth of his smile radiating out to all of us, no matter where he was. I'll hold this moment in time close to my heart forever—he passed away only fourteen days after the photo was taken. I know he's smiling down on all of us . . . It was always his way. Love, Wendy

Dear Photograph,

As the girls get ready to leave for college, I hope they remember the important stuff—things like don't cry over spilled milk.

Love, Jill

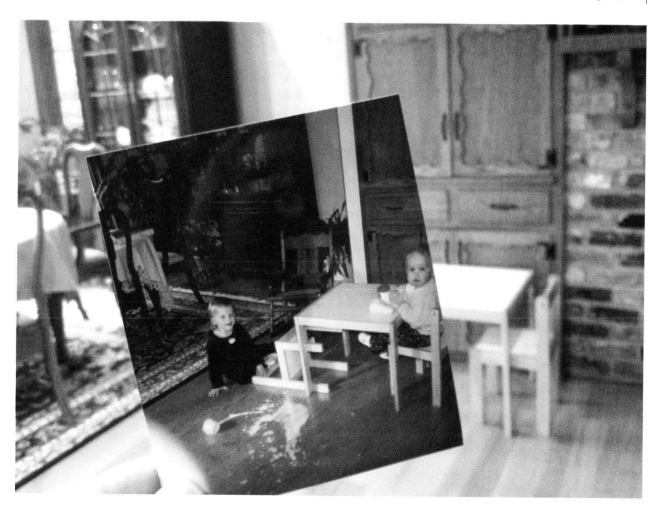

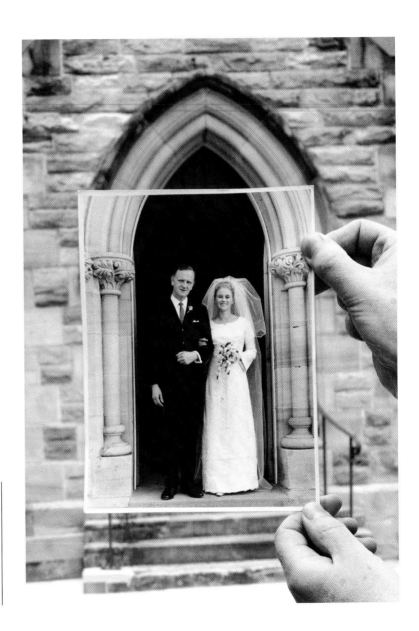

Dear Photograph,
The church doors opened wide, and out came the happy couple, who would love each other for a lifetime. This is where your love began, and this year you met again at heaven's door.
Miss and love you both, Lesley

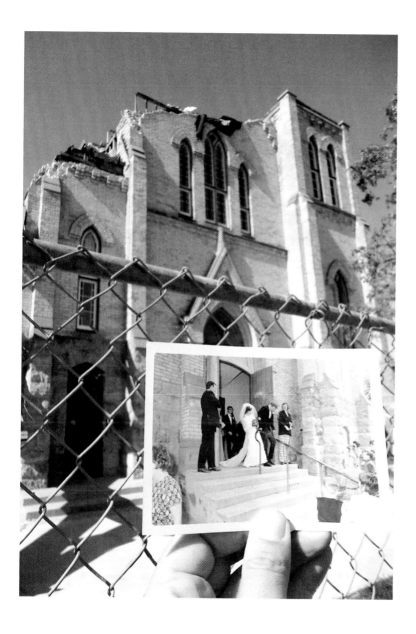

Dear Photograph,
Bricks and mortar may not hold up to an
F3 tornado, but it could never tear apart
my aunt and uncle's love for each another.
Jacki

Dear Photograph,
I miss those hot summer days in Segovia, just like I missed that
ball I tried to catch. Three decades later and I'm still trying!
Alfredo

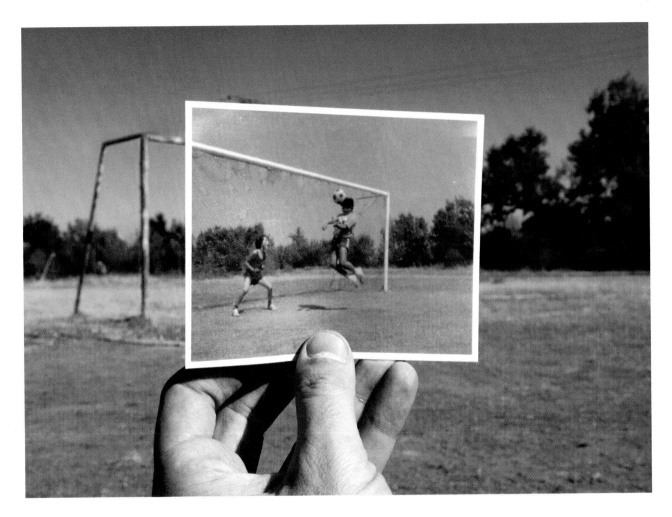

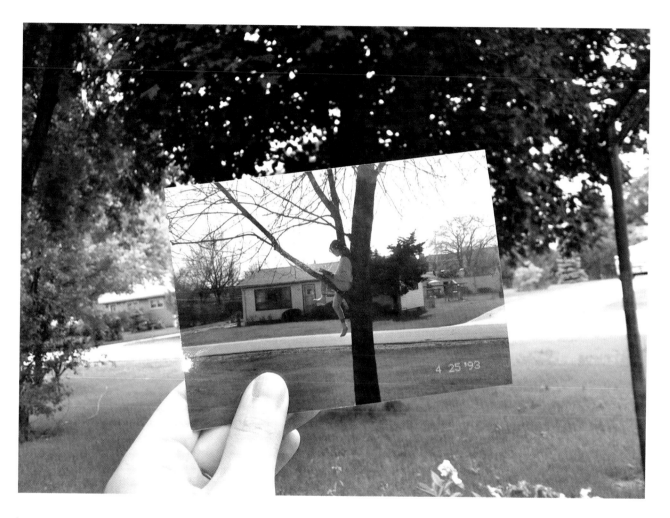

Dear Photograph,
I climbed this tree and read books all summer
until all the leaves fell down.
Jean

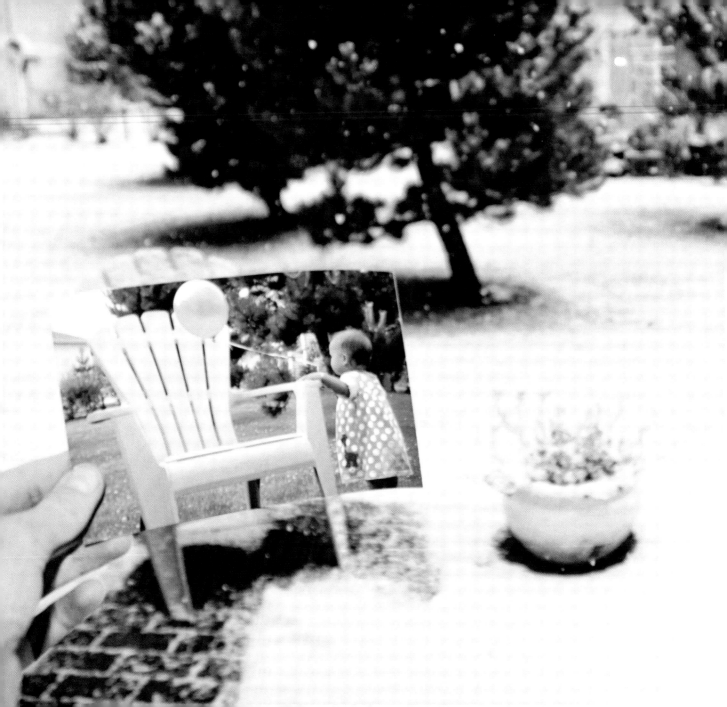

Dear Photograph,
A simple yellow balloon or the first
snowflakes of the season always made my
girls giggle and look with such wide-eyed
wonder. I cherish the life lessons they
have taught me.
Mamma

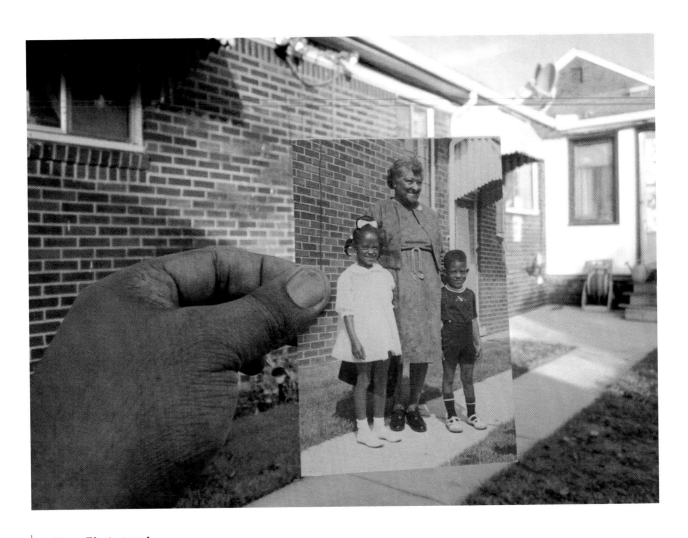

Dear Photograph,
The sun always shone brighter when our grandmother was beside us. Even though I was never allowed to say good-bye, I still felt her radiant spirit when she left us to go to heaven. We miss her so much.
Ivan

Dear Photograph,
Your flag and World War Two medals sit on my shelf and I look at them frequently, wishing I'd paid more attention to your stories. I miss those vanilla milkshakes we used to get while you'd flirt with the waitresses. Andrew

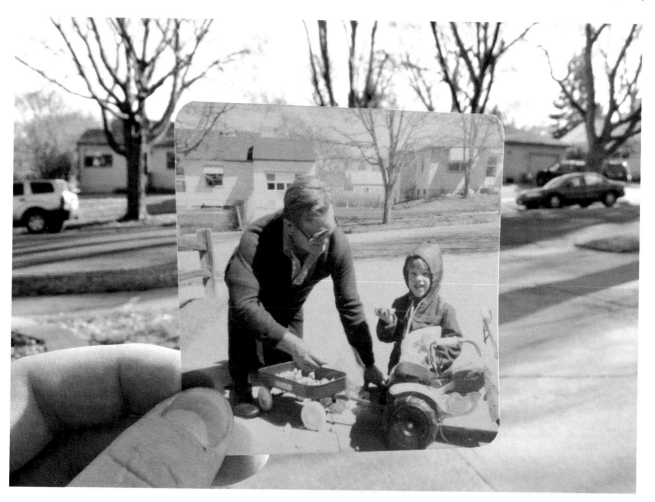

Dear Photograph,
Fifty years ago my mom stepped off her porch and was swept away
by bonds of love and friendship that remain strong to this very day.
Love, Greg

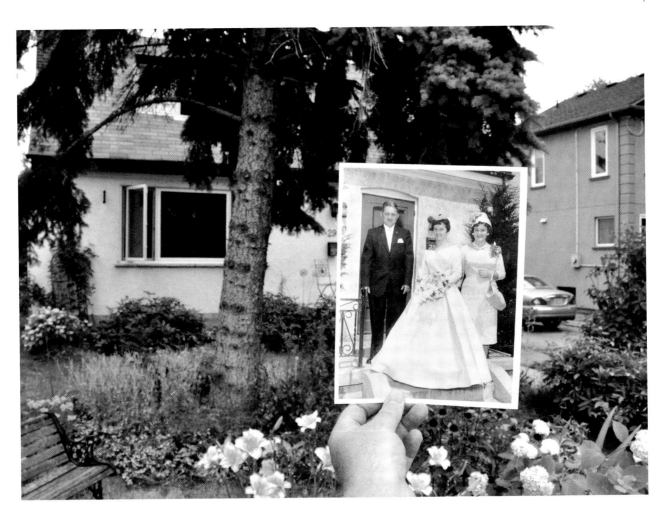

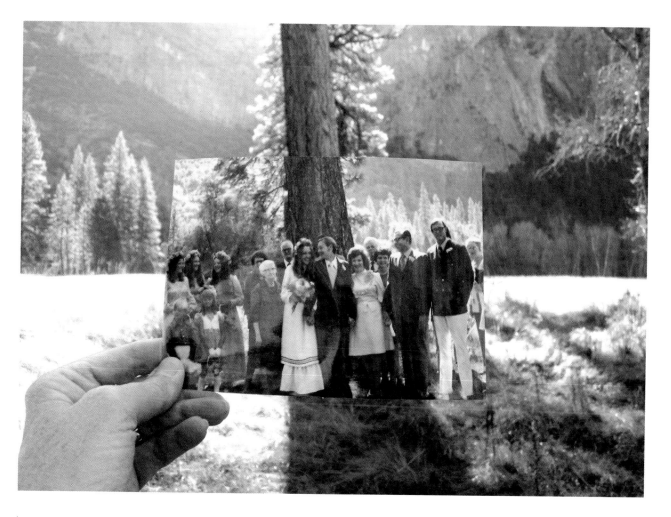

Dear Photograph,

Forty years have passed since our wedding in Cook's Meadow, Yosemite National Park. As we look at the smiling faces of our friends and family, we'll always remember their love on this special day. Beauty truly has been all around us, always. Carol and Rae

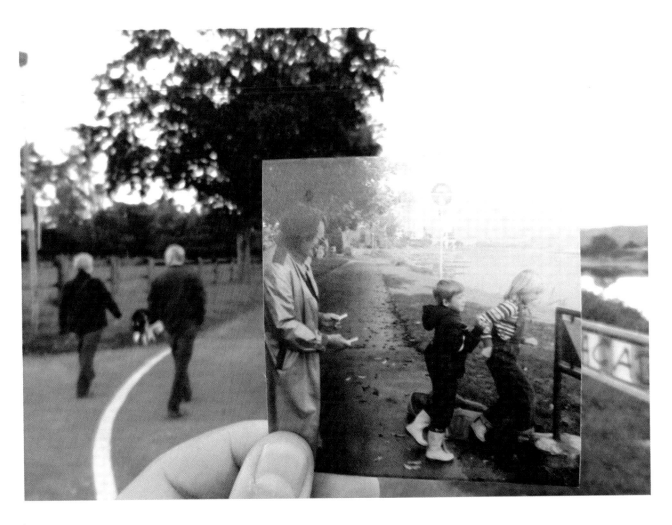

Dear Photograph,
Grandma always tried to bribe us with a stick of gum to keep us
from misbehaving. I think of her every time I chew one!
Ursula

Dear Photograph,
No new owner will ever truly know the steps of that house:
who walked down them, fell up them, and was loved while sitting on them.
Danaé

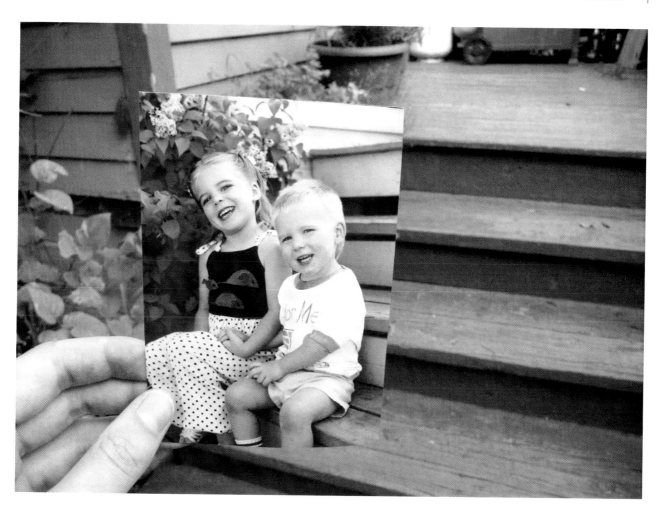

Dear Photograph,
My parents came to the United States
as Peruvian immigrants with very little
money, but I had not a worry in the world.
Thanks for the great childhood, Mom and
Dad. I never felt anything but loved.
Ronnie

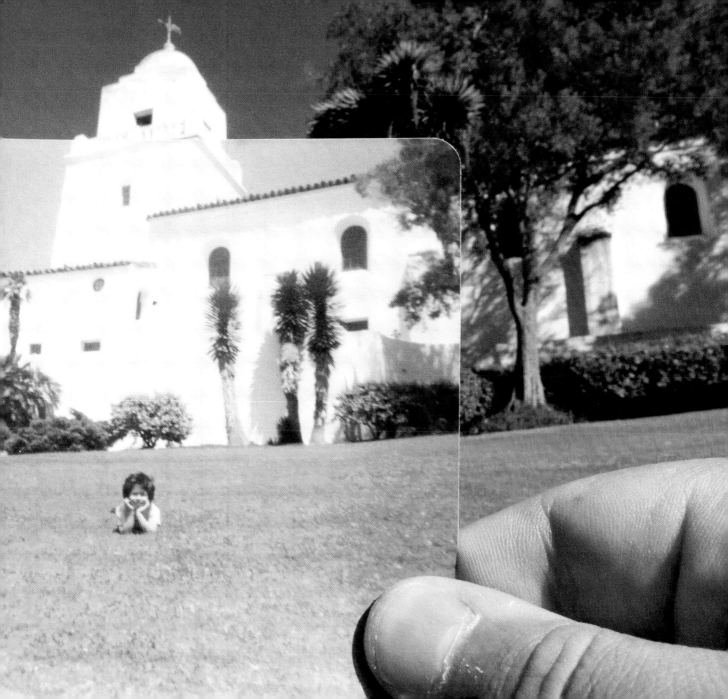

Dear Photograph,

Grandpa Joe was a retired United States Postal Service letter carrier, World War Two vet, homemade wine maker, and garlic-growing, sauce-making second-generation Sicilian immigrant. With his love for a life full of flavor, he is busy, I'm sure, in the gardens of heaven. He meant the world to me. Love, Mark

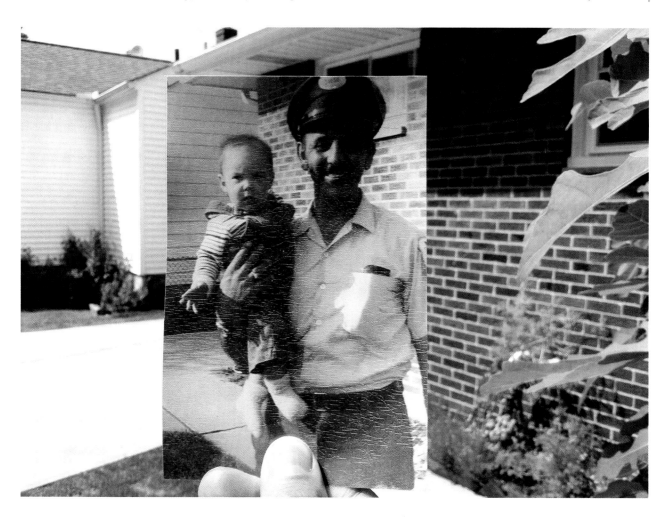

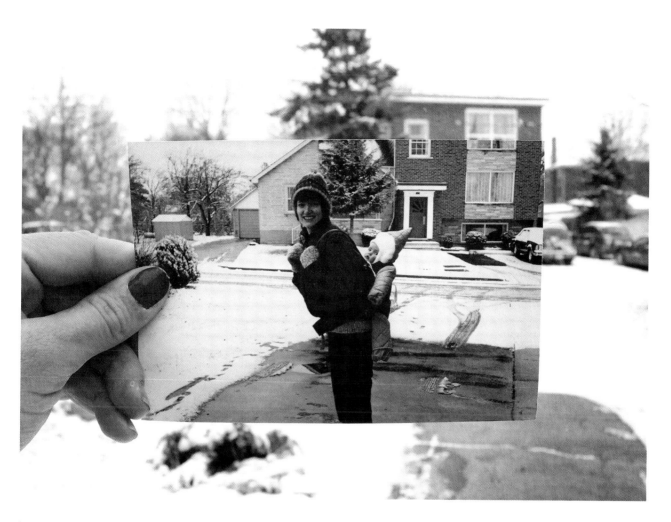

Dear Photograph,
The road I traveled in life was always better when she came along.
I loved hanging out with my mum and still do.
Casie

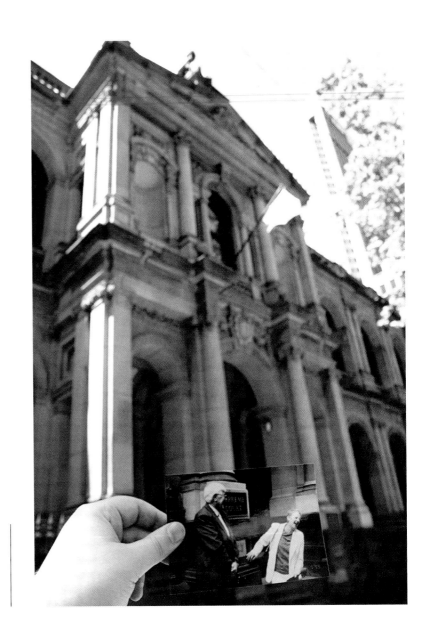

Dear Photograph,
My father could make anyone laugh,
especially my mother.
Michael

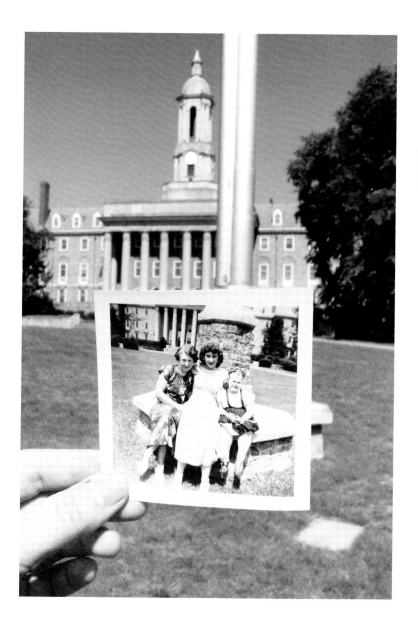

Dear Photograph,
When he broke my heart, you hugged me tight and said, "If it's meant to be, it will happen." Little did I know how much that piece of advice would help me throughout the rest of my life.
Chloe

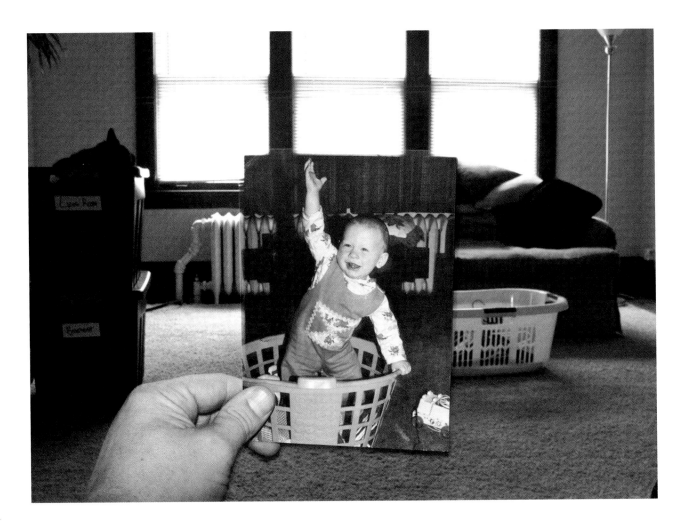

Dear Photograph,
I'm thirty-three years old and finally moving out of my parents' house.
This time it's for real.
Ben

Dear Photograph,
Sitting on the counter, swinging my legs, and licking the brownie batter
off the beaters. Those memories with my mom are still unbeatable.
Nina

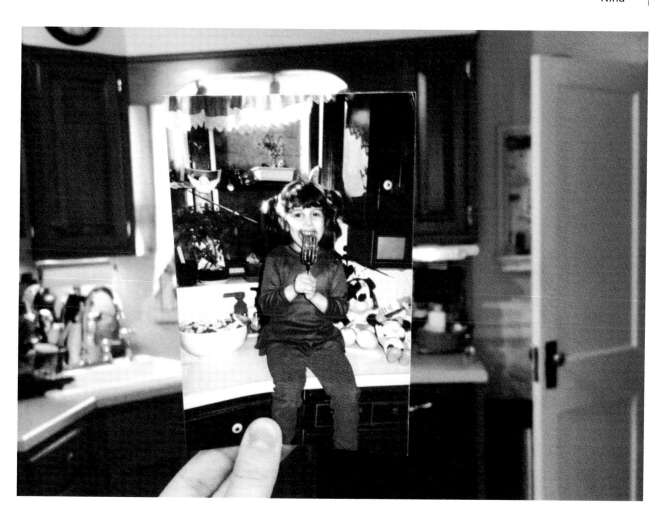

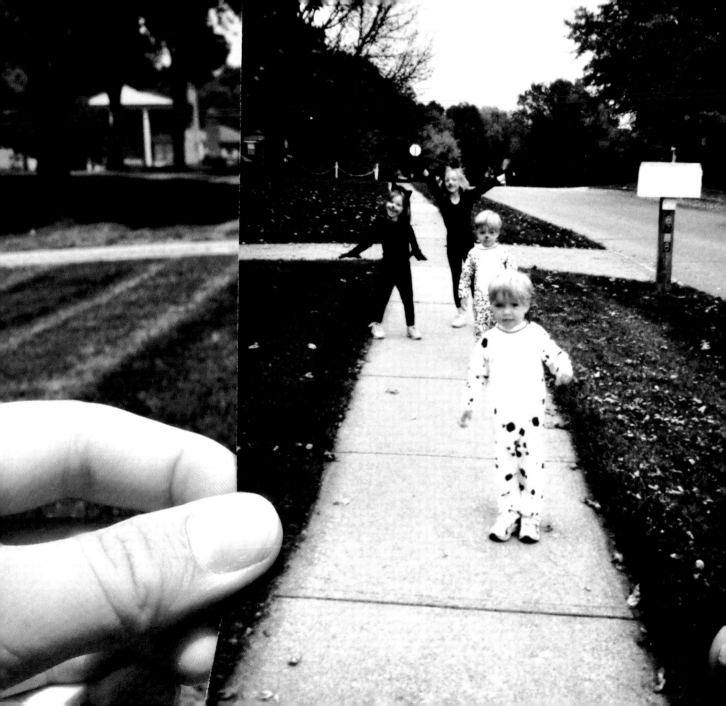

Dear Photograph,
Why can't I feel all the color that
Halloween used to bring me? It's
hard to see the magic through
grown-up glasses.
Paisley

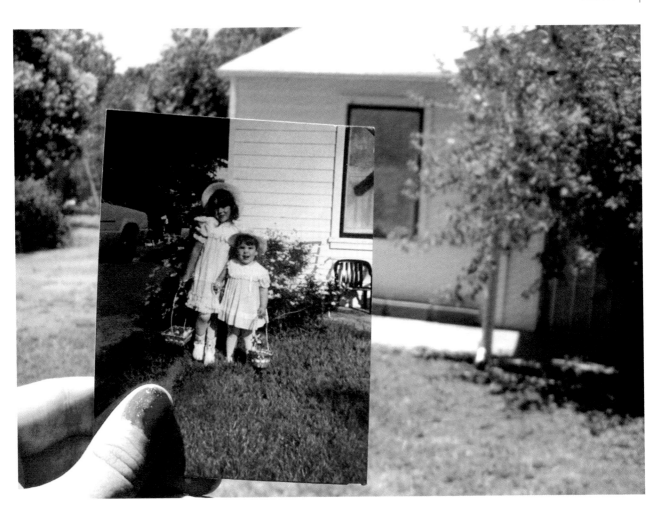

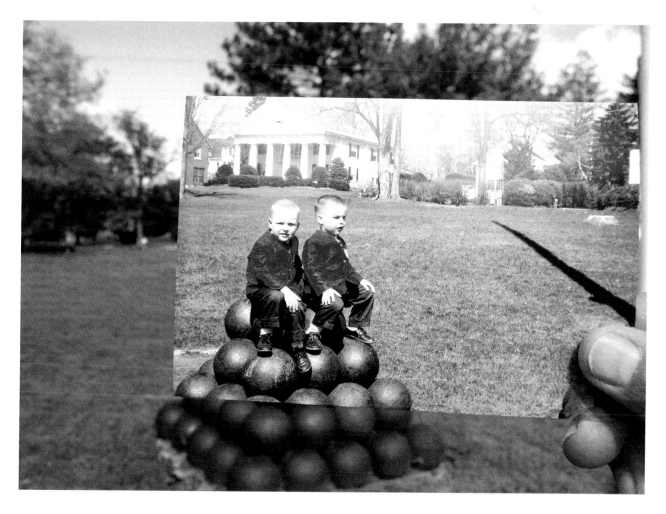

Dear Photograph,

Forty-some years ago, we were sitting on top of the world having a blast. I sure could use a little gunpowder to get me going these days.

Paul

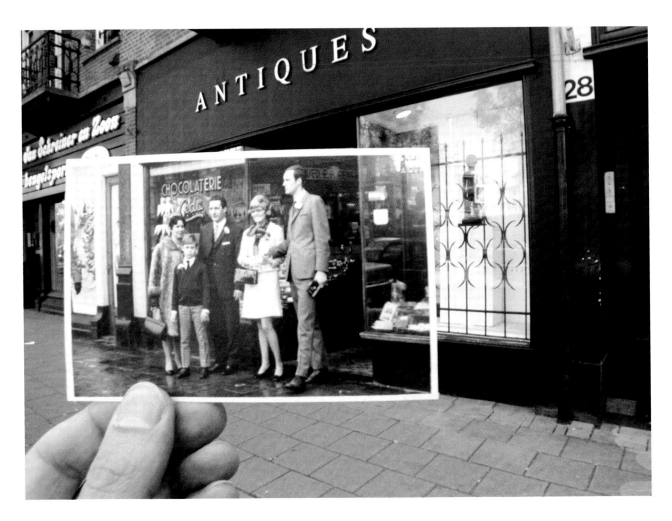

Dear Photograph,
Our wedding day was our sweetest, just like Grandma's chocolate.
Onno

Dear Photograph,
Celebrations of the heart matter.
Susan

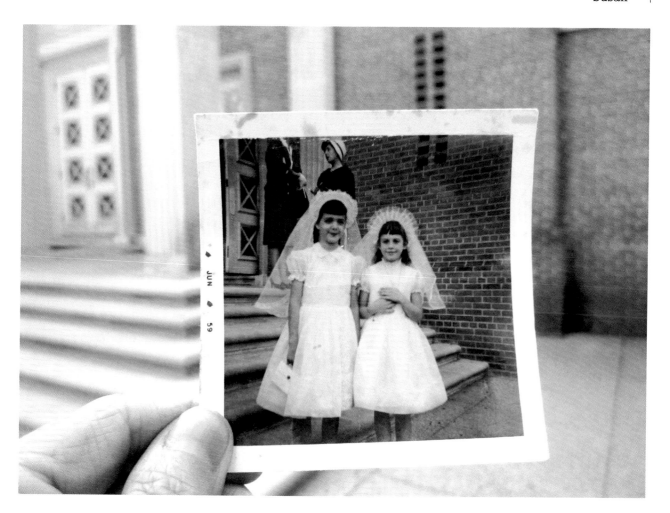

Dear Photograph,

For more than thirty years, Grandpa would meet me at the guava tree to walk together back to his farm. I know that he still guides me on which road to travel in life, even if it is from heaven.

Anderson

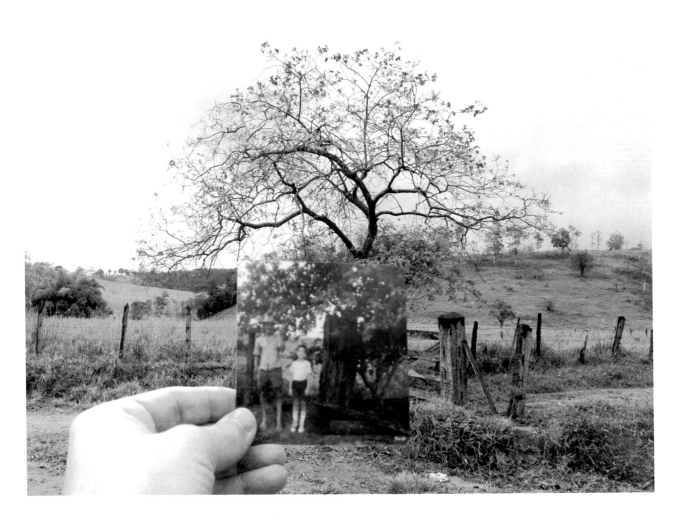

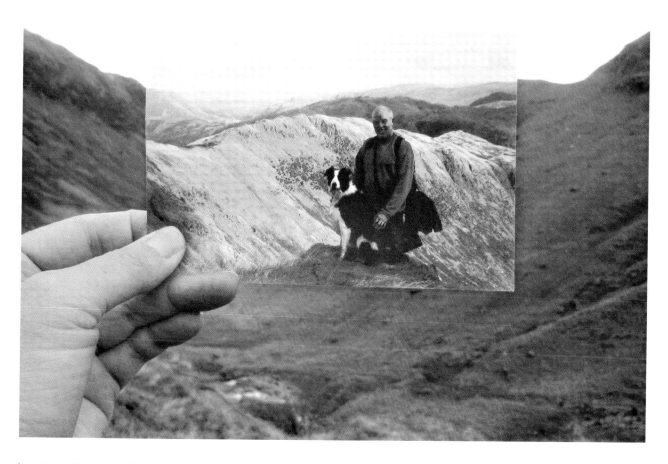

Dear Photograph,
This one is for you, Callum—you loved running around in the
hills, covering ten times more ground than anyone else.
Love, D&M&G

Dear Photograph,
My youngest son hated to have his
picture taken. No birthday party or
lavish gift could ever get him to show
us his pearly whites. As soon as that
old Brownie camera came out, so did
his thundercloud frown. Ironically,
forty-four years later, comedy
became his favorite genre.
Helen

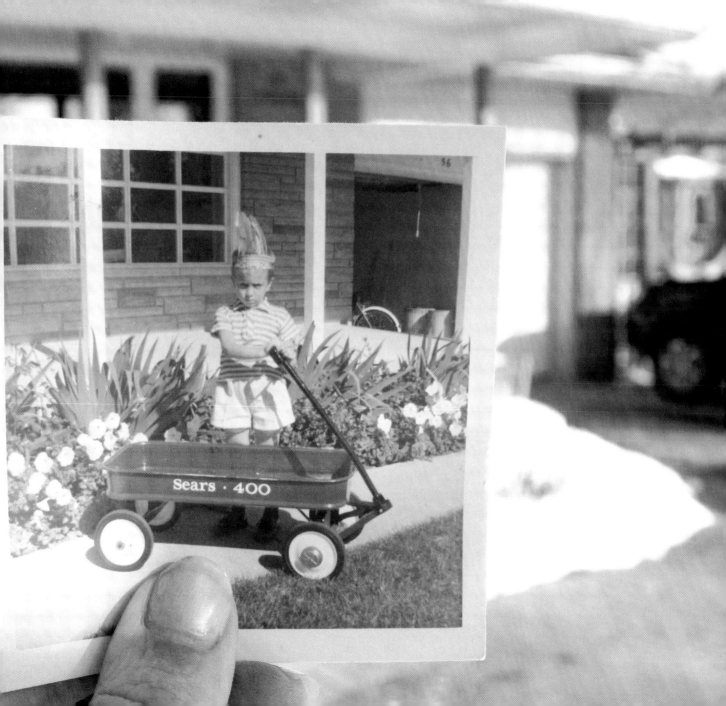

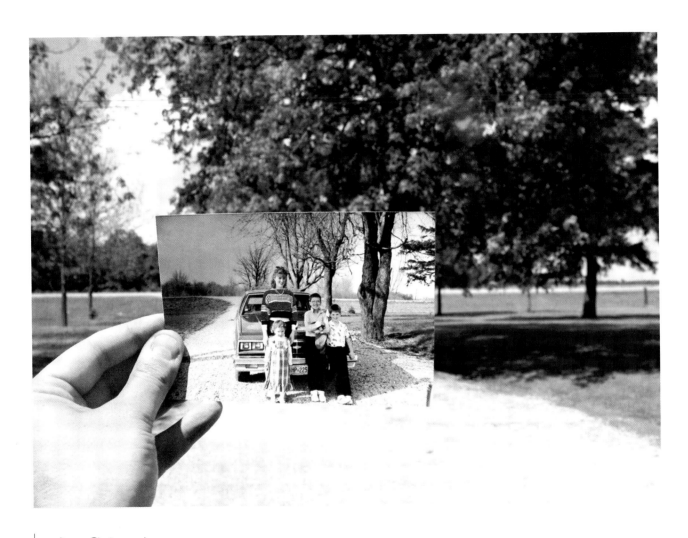

Dear Photograph,
Thank you for reminding me that when the road is long, there are always kind people waiting to pick you up.
Ben

Dear Photograph,
Me with my first bike. The bike I have now goes a little bit faster.
Aaron

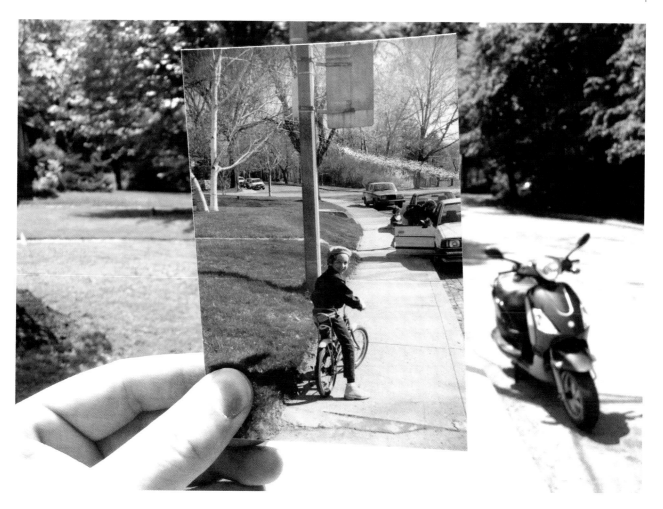

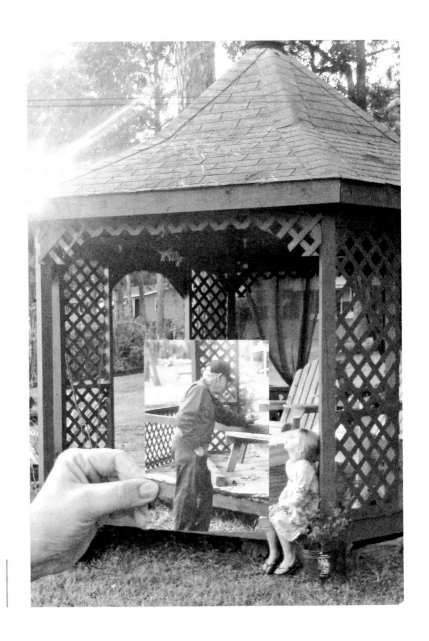

Dear Photograph,
We always loved you, rain or shine.
Love, T.J.

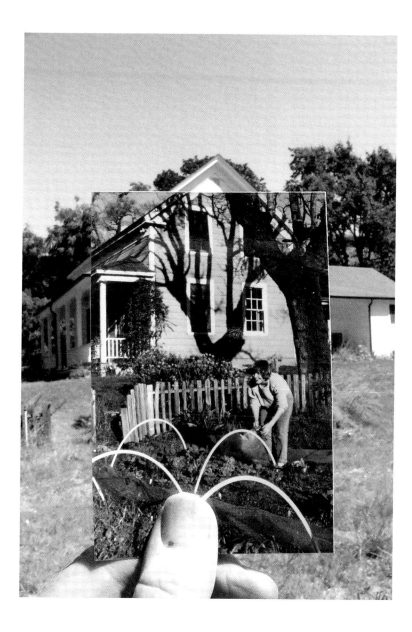

Dear Photograph,
Seasons come and go. Even the walnut tree is a ghost. Yet the old farmhouse endures, and we are glad to be its stewards.
T. and E.

Dear Photograph,
My dad drove over twenty-four hundred miles to take me fishing on the Gallatin River every summer of my childhood. Now I drive over fourteen hundred miles each summer to make sure my kids enjoy the same tradition. I hope they'll carry it forward for generations to come. Linda

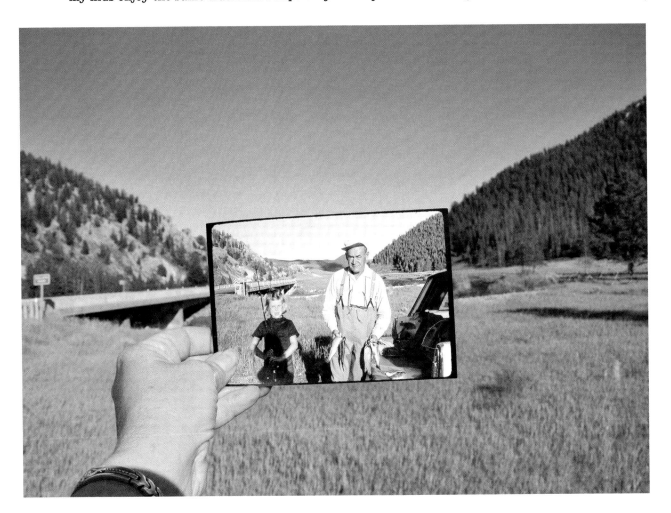

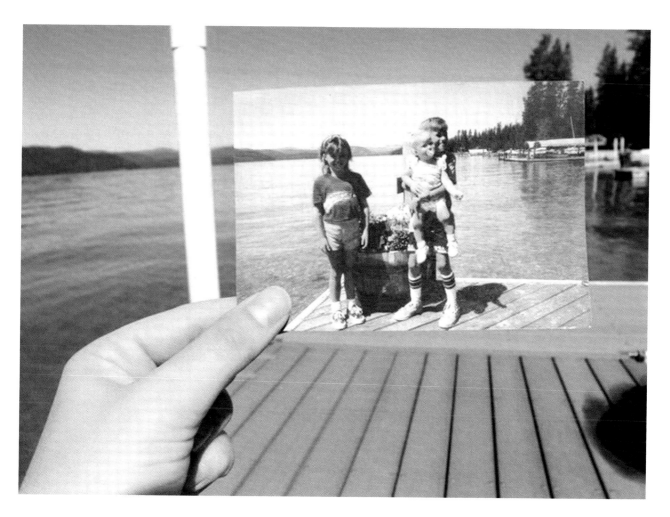

Dear Photograph,
Twenty-three years ago you couldn't keep us apart; now
I just wish we could get along. I miss my brother and sister.
Danae

Dear Photograph,
Kasey ran his school's five-kilometer race in sandals and won the grades five to eight division as a sixth grader. As he ran by, looking over at the cemetery, who would've known that one short year later he would be buried there? It has been twelve years since Kasey died in the fire, and I miss him so much. I wonder what kind of man he would be today at twenty-four years old. Life can be so very fragile. Make the moments count.
Kris

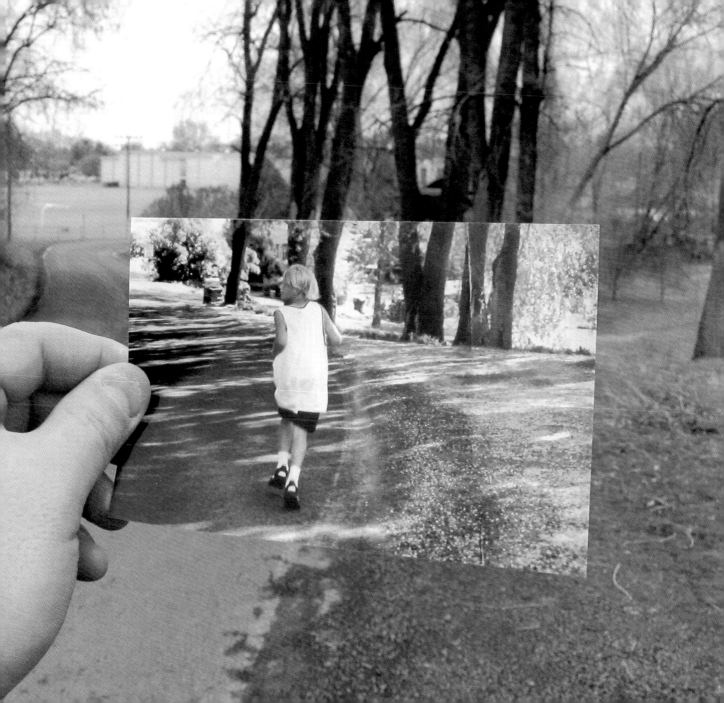

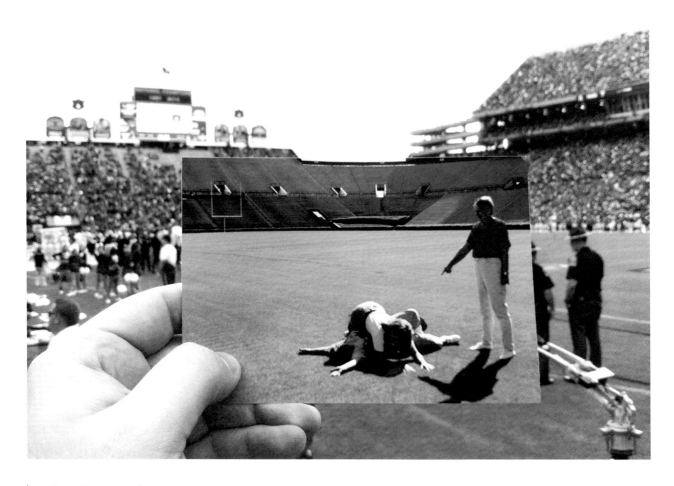

Dear Photograph,

I've watched a lot of great football games over the past twenty years at Auburn. But seeing my mother tackle my grandmother is still one of the all-time hall-of-fame moments for me.

Kenny

Dear Photograph,

I wonder what my cousin was thinking about. I'm sure losing his life to cancer ten years later was nowhere to be found in his thoughts as he fished and dreamed the day away. Sometimes I sit by Grandpa's pond and wonder if my cousin knows just how much I miss him. I'd give anything to have him back. Sincerely, Andrea

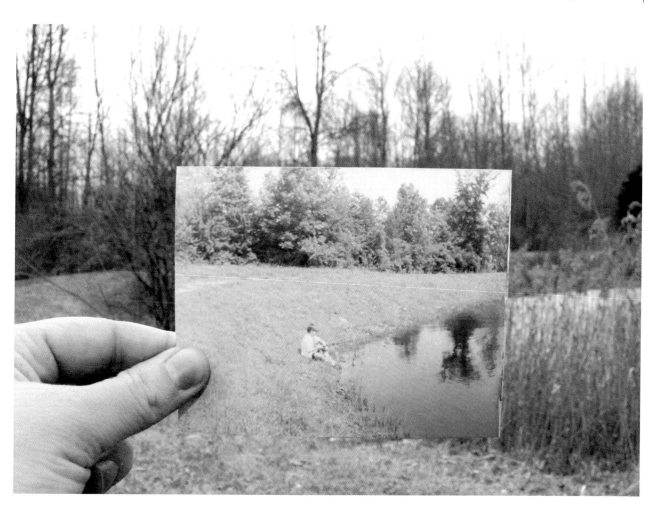

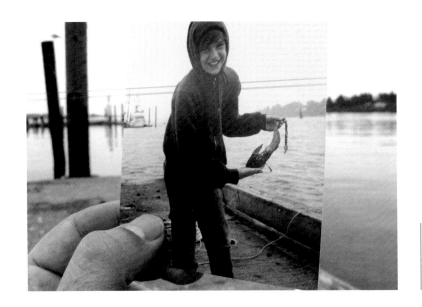

Dear Photograph,
I wasn't planning on fishing
for sushi!
Todd

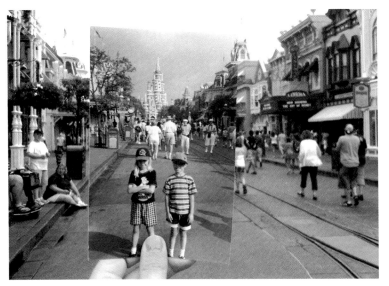

Dear Photograph,
Disney will always be magical,
no matter our age.
Leslie

Dear Photograph,
We were never cold in that house.
Christian

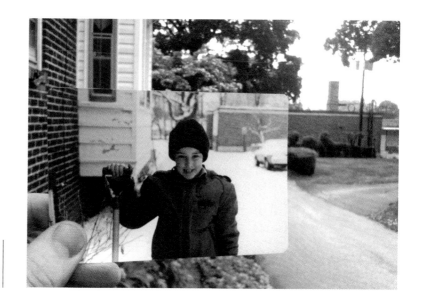

Dear Photograph,
Young and innocent, we were
family back then. We all went our
separate ways, and eventually we
came back to live in the same city.
Thing is, none of us talk to one
other anymore. How can we be so
close, yet so far apart?
Jim

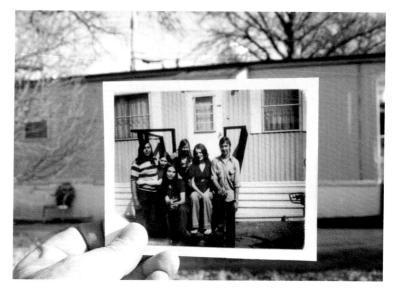

Dear Photograph,
I thought Dad never took a picture of me, ever. Then I noticed his reflection in the glass.
Gregg

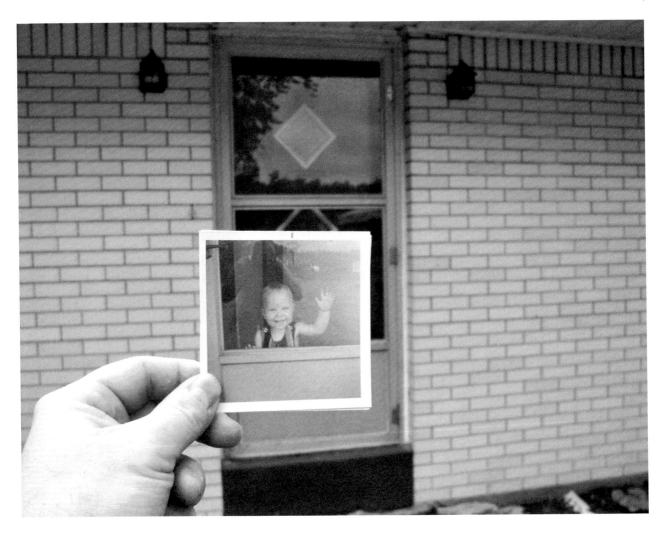

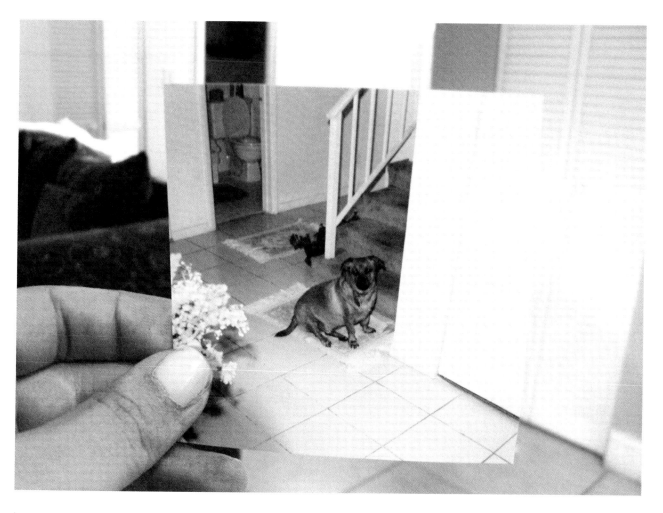

Dear Photograph,
Please tell Tobby I love him. I'm so sorry I didn't have the courage to say good-bye.
Always in my heart,
Michelle

Dear Photograph,
My mom was on to something with
all her planting, I can see that now.
When things get rough, find a little
piece of earth and hold on. There's
beauty to be had in the end.
Love, Allison

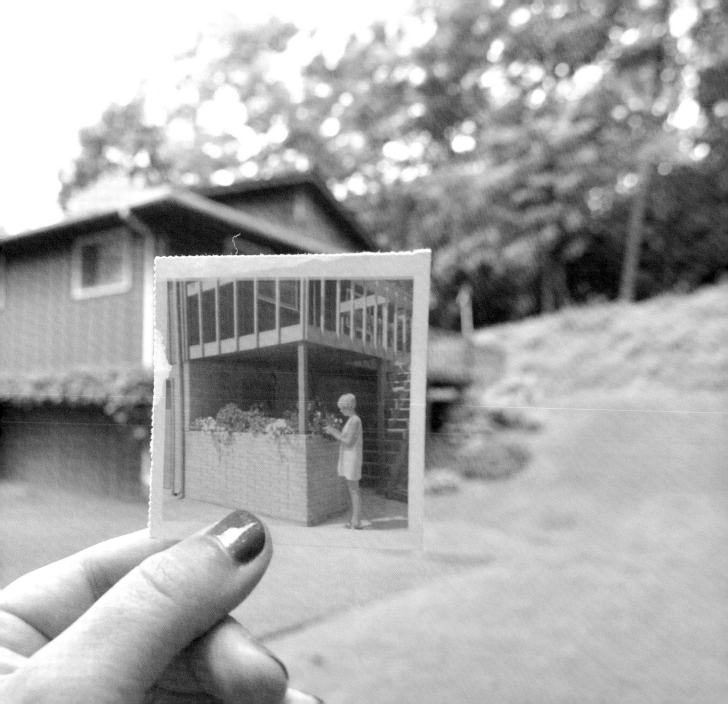

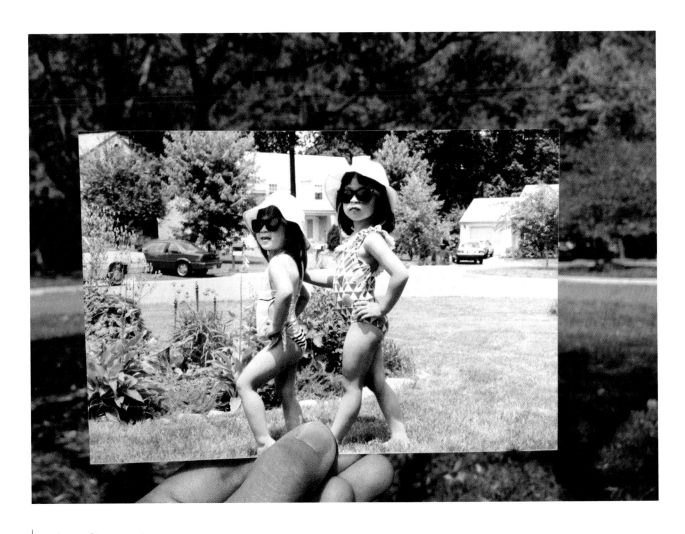

Dear Photograph,
It's been over twenty years, and my little sister is still the one with all the attitude!
Natasha

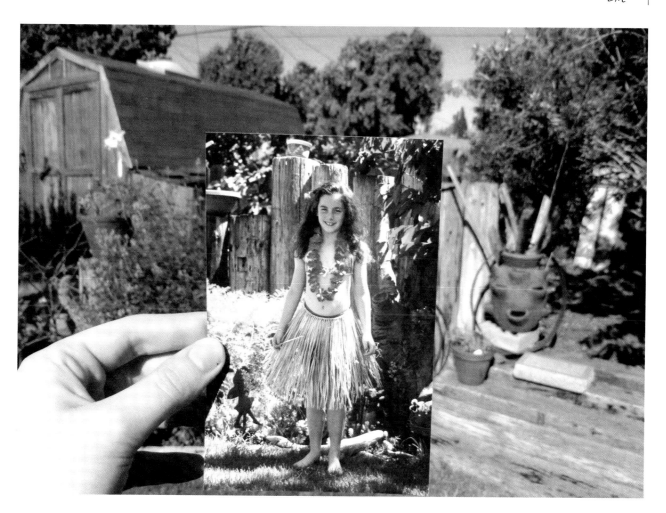

Dear Photograph,
I wish I was still this comfortable wearing little or next to nothing.
Em

Dear Photograph,
Tell her to come to me. I'm ready and waiting, with open arms, to embrace my inner child once more. At fifty-five years old, I'm finally coming into my own.
Sylvia

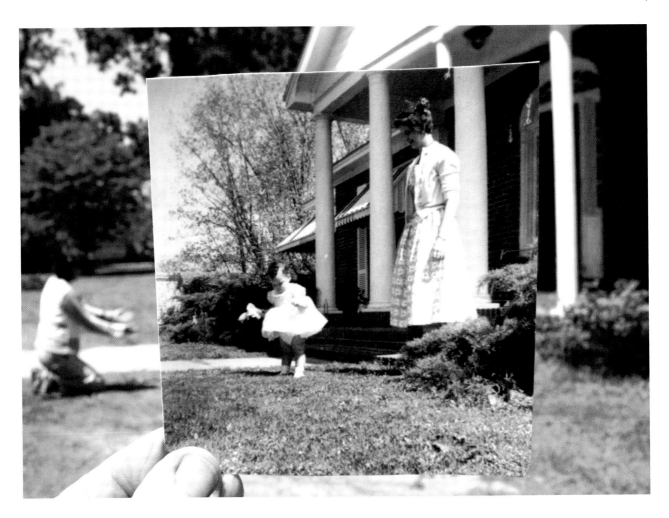

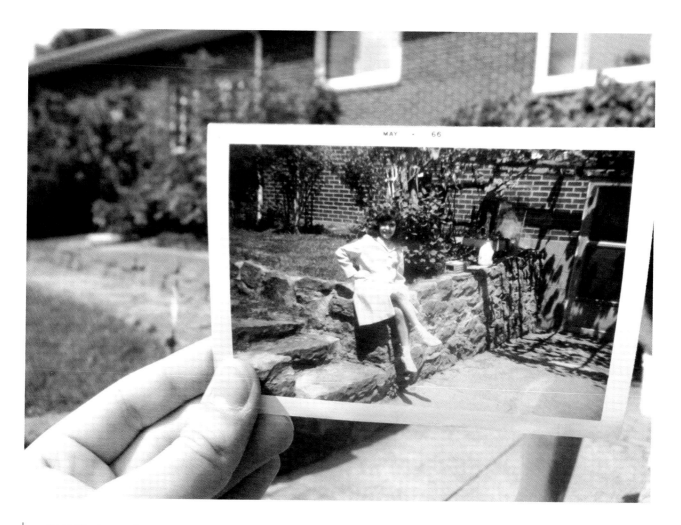

MAY · 66

Dear Photograph,

This wall held my mother up so many years ago. Now we're
back again, holding up each other and Grandpa.

Milena

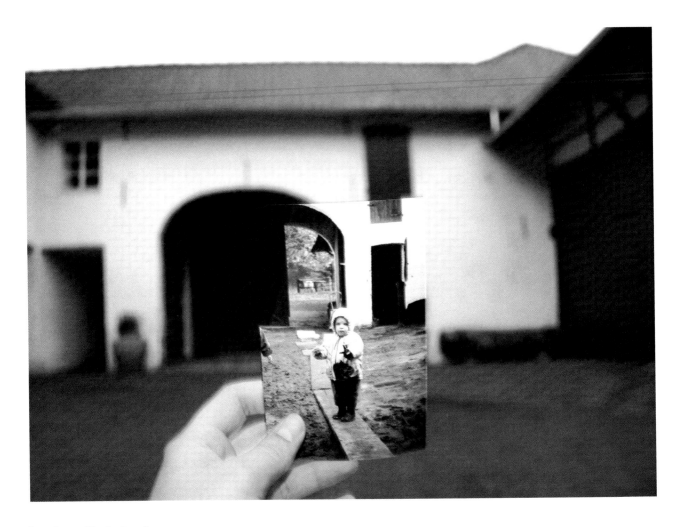

Dear Photograph,
Even when life has everything all lined up, sometimes you need to
break all the rules and just dig in.
Judith

Dear Photograph,
West Point is where we first pretended we were soldiers.
Forty years later, we're both army veterans.
John and Rob

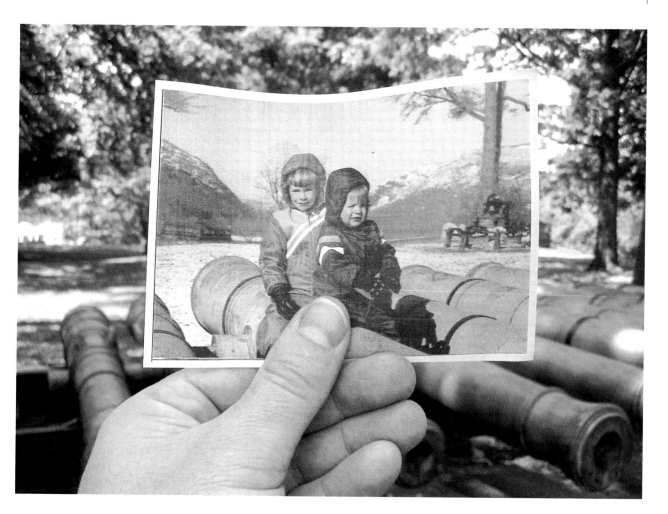

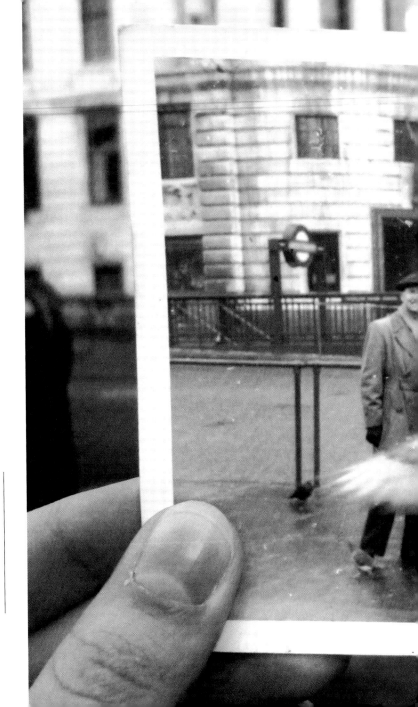

Dear Photograph,
Trafalgar Square, fifty years ago—
my granny never looked happier! If my house
was burning down, this photo would be the
one possession I would be desperate to save.
I miss so many things about my granny, but
most of all I miss her beautiful smile.
Clare

144

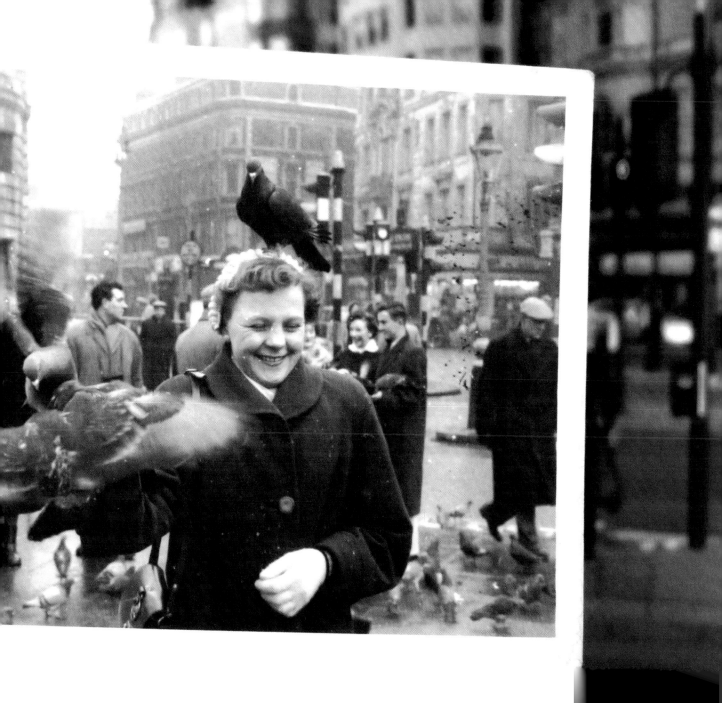

Dear Photograph,
Where we used to stand in Feethams, the grass may be overgrown, but my memories
of cheering on the Darlington football team as a young boy are not.
Jon

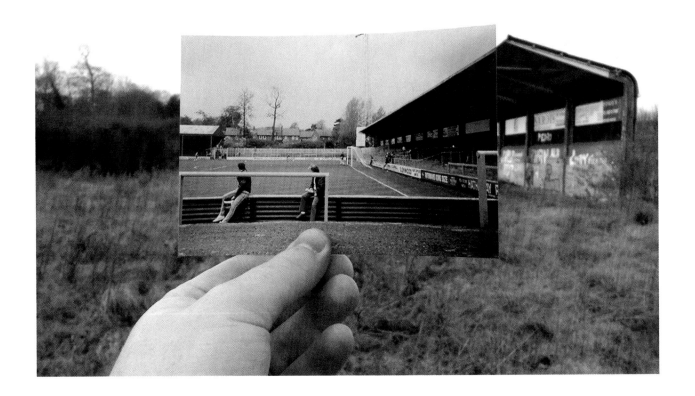

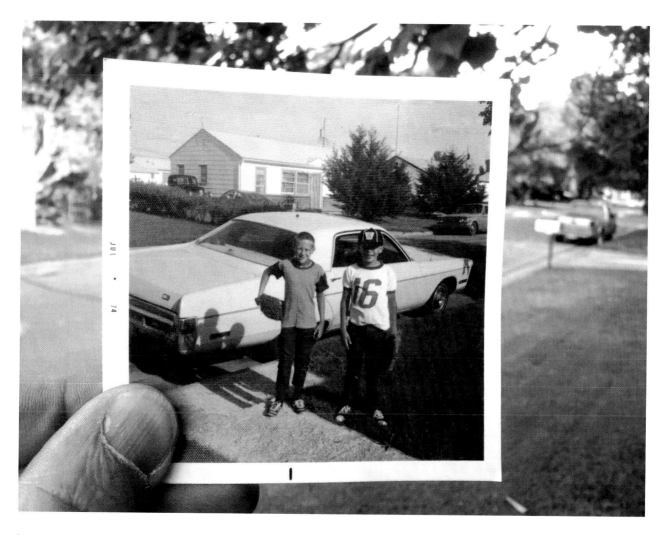

Dear Photograph,
Now I know when I started wearing the ringer-T and ball cap look.
Darrin

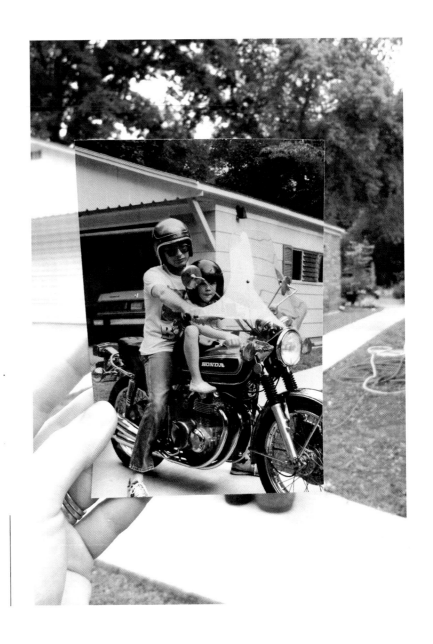

Dear Photograph,
I was the coolest five-year-old
easy rider ever, all thanks to Dad.
Love, Joanna

148

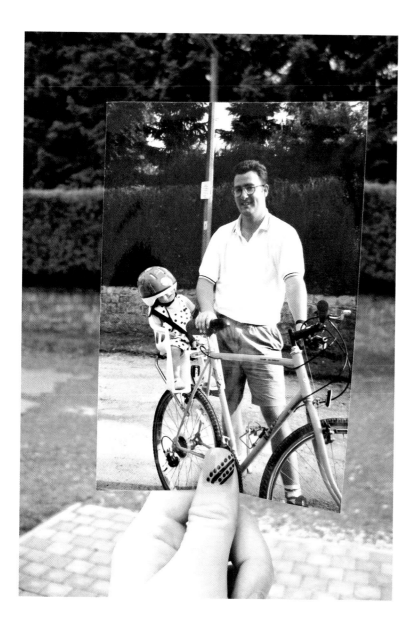

Dear Photograph,
Sixteen years later he still loves to
ride his bike, without me in the back,
of course.
Ellen

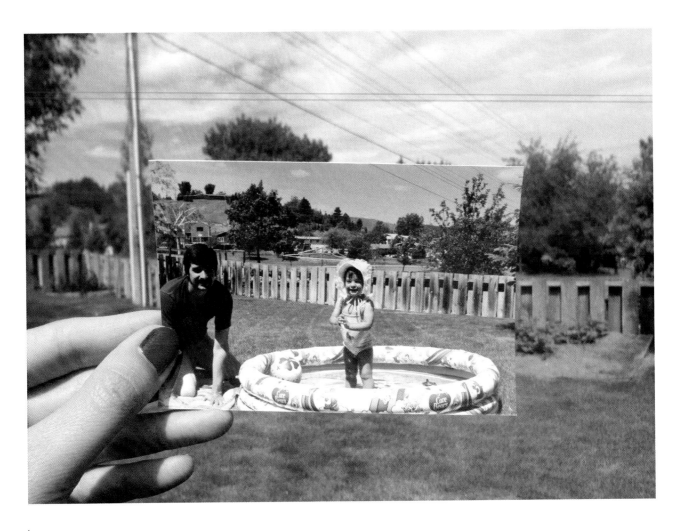

Dear Photograph,
You gotta love being a daddy's girl. Even
twenty-five years later, it's who I am!
Leah

Dear Photograph,
Over thirty-two years, my dad and I have run many races together. It's been a marathon of love, advice, and friendship, and we still haven't crossed the finish line.
Love, Benoit

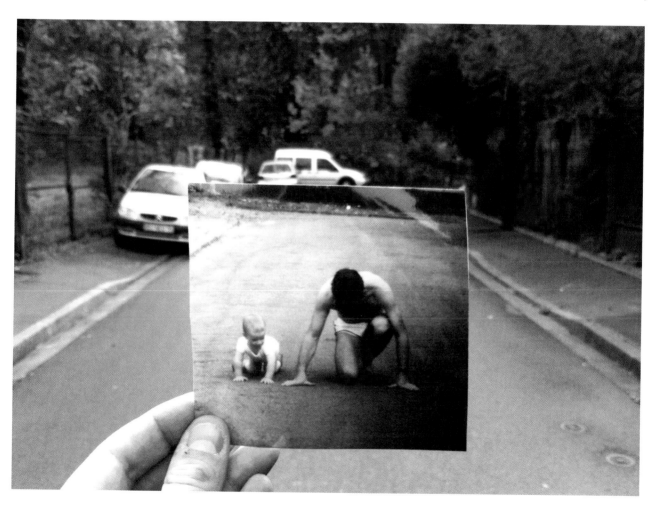

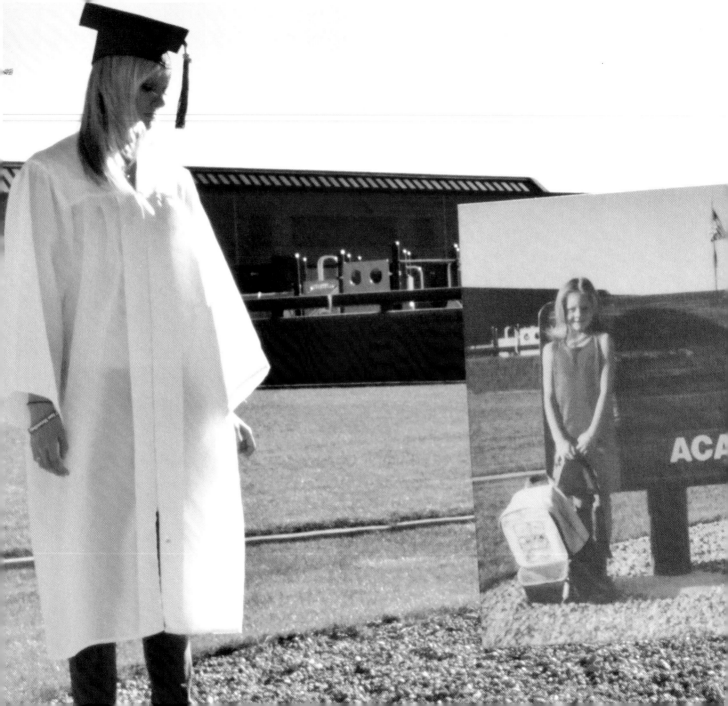

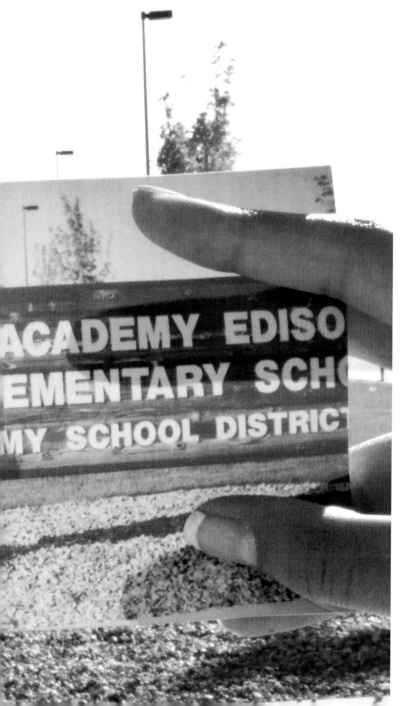

Dear Photograph,
From your first day of kindergarten
to your high school graduation, time
traveled too fast. I wish we could go back
and live it all over again.
Christy

Dear Photograph,

Christmas in 1973 in Lisbon, Portugal, was so magical. When Santa Claus came to town, my grandfather took me to see him and have my photo taken. That love for my grandfather is still my favorite gift all year round.

Miss you, Ana Teresa

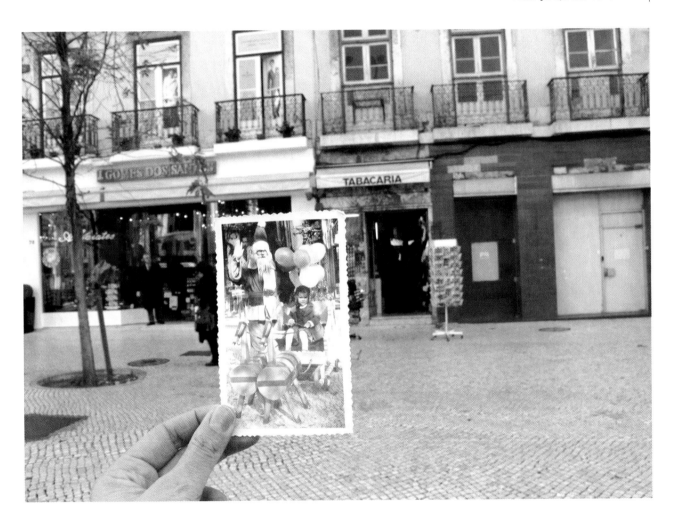

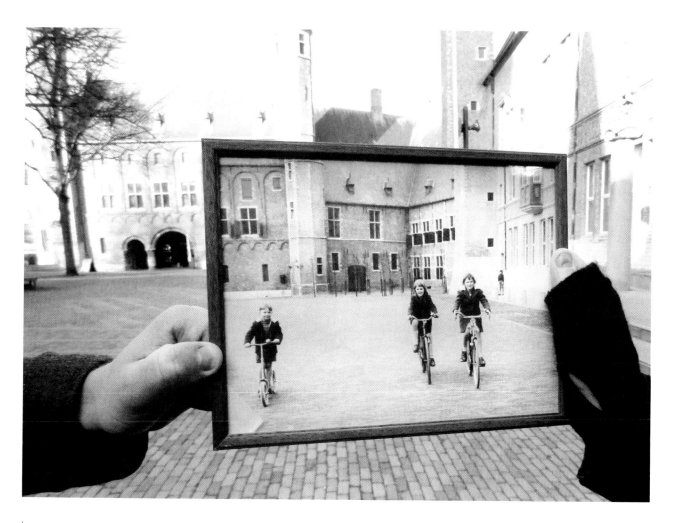

Dear Photograph,

My mother had no idea that she and her brother and sister would learn that year to journey through life without their mother by their side. Grandpa carried on and took care of all three children all by himself, taking lots of pictures along the way. I'm sure my grandmother was looking at those pictures over his shoulder. Helen

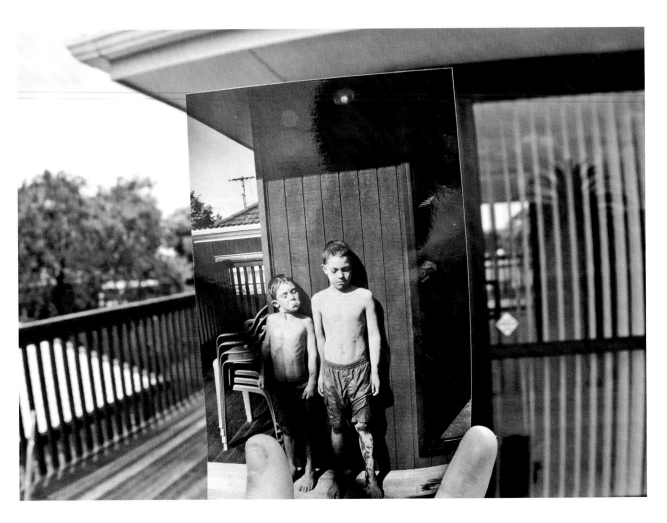

Dear Photograph,
Hot New Zealand summer days set two bored young brothers' imaginations on fire. We grabbed a sheet of plastic and the garden hose, and turned the backyard into one big waterslide. Mum knew it would be the end of the grass, and we thought perhaps the end of us. Sure enough, the grass grew again, and so did we. Craig

Dear Photograph,
Let me go back in time and have one more day to ring the doorbell at my grandparents' home
and let them know we are here to play. I promise I will enjoy it even more!
Bojan

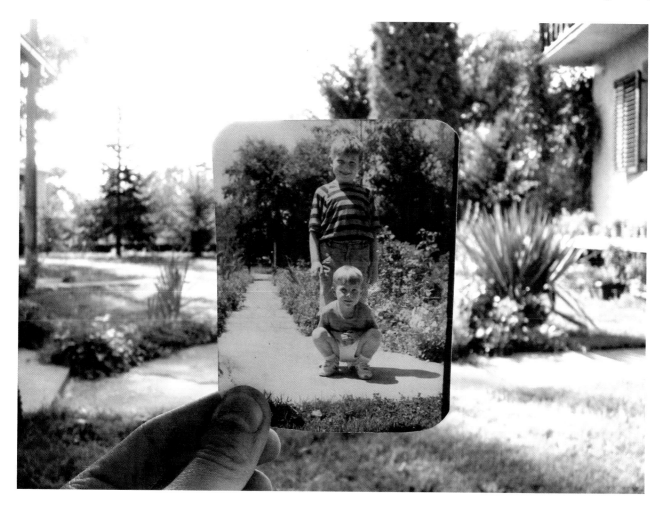

Dear Photograph,
Gone are the days when I would spend hours spit shining my Big Wheel.
Please send that little boy to clean that dirty white car.
Eric

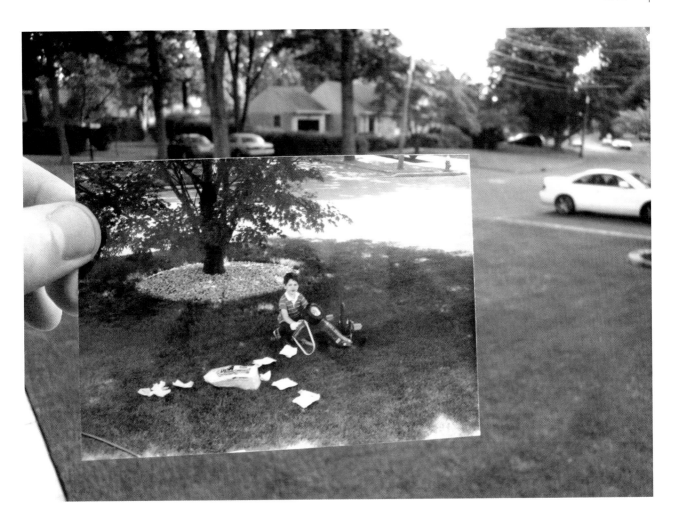

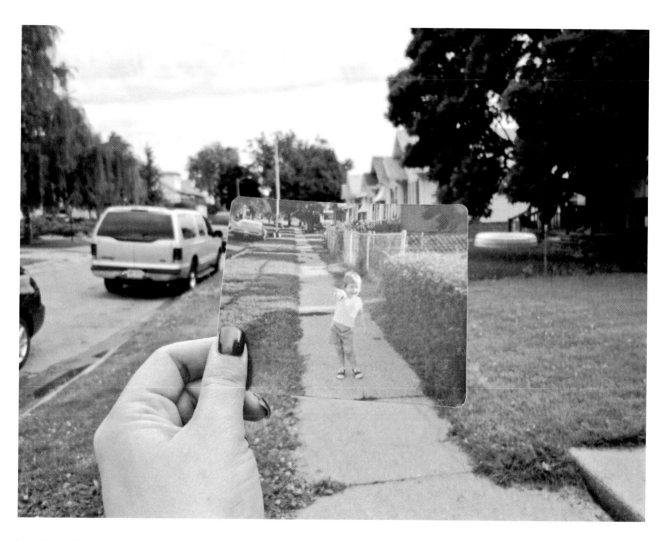

Dear Photograph,
I'm still blowing kisses!
Carolyn

Dear Photograph,
If I had turned around, would
I have caught a glimpse of my son
coming up the road?
Steve

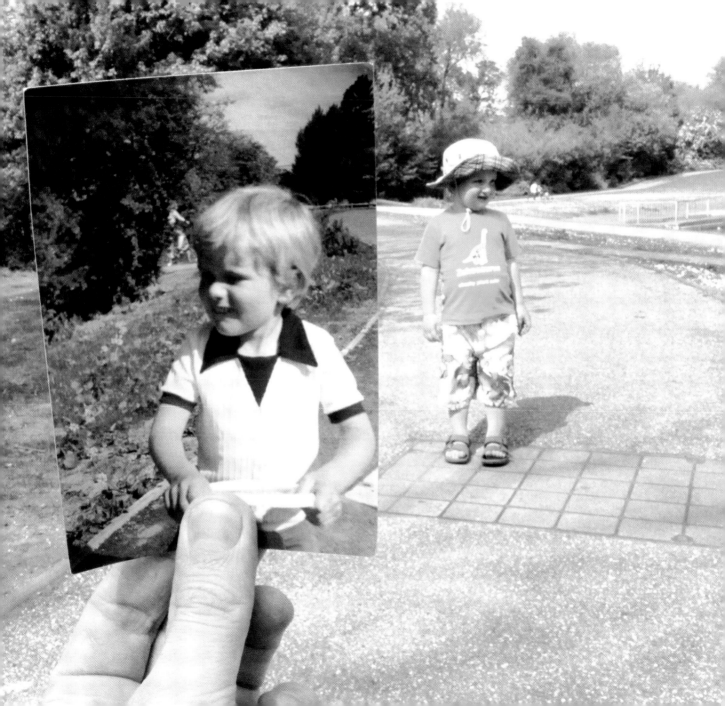

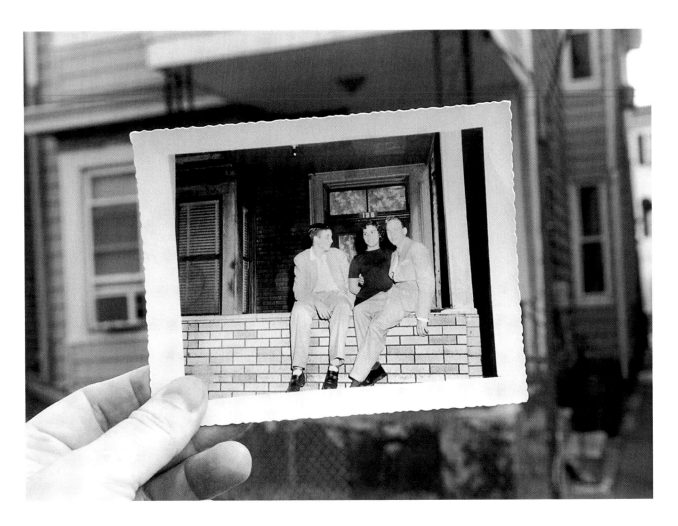

Dear Photograph,
My grandparents eloped long ago, and Grandpa always said she was the love of his life till the day he died. They really did live the American dream.
Chris

Dear Photograph,
At the time it was not common for a man to walk
behind a pram. I'm so proud of my father.
Eva

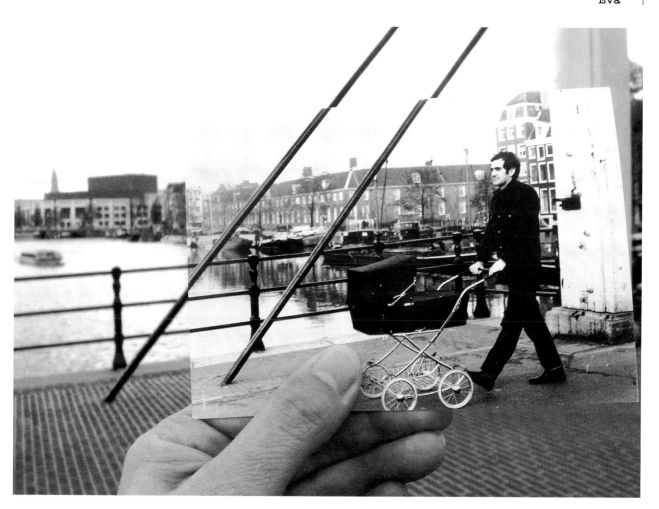

Dear Photograph,
East LA was where my parents
bought their first house, and they still
live there today. I sure was one cool
new kid on the block!
David

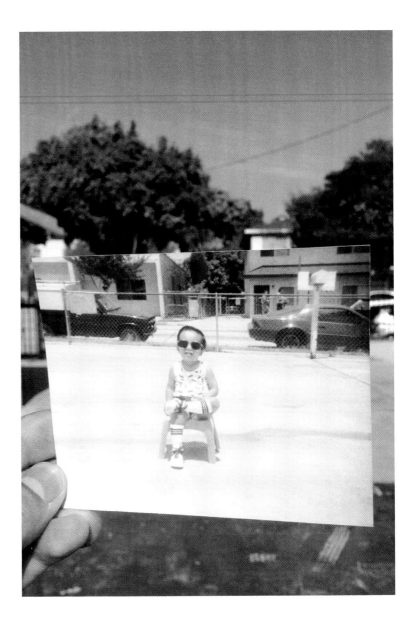

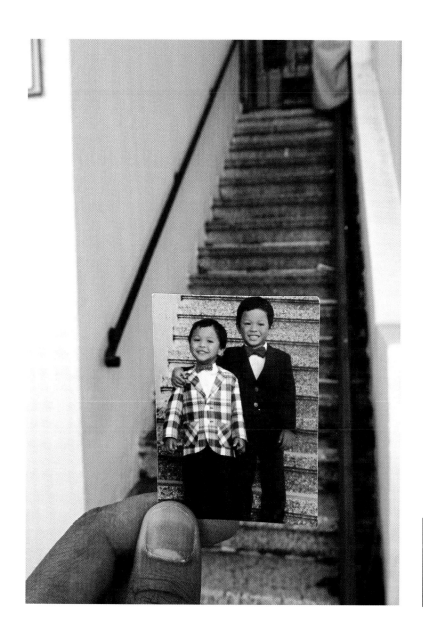

Dear Photograph,
One day he'll be the best man at my wedding, and we'll be wearing the same suits.
Joshua Manongdo

Dear Photograph,
If I could play all day like that again, with nothing weighing heavy on my shoulders,
I'd cherish every moment. I miss that kid. I wish I could find him.
Eric

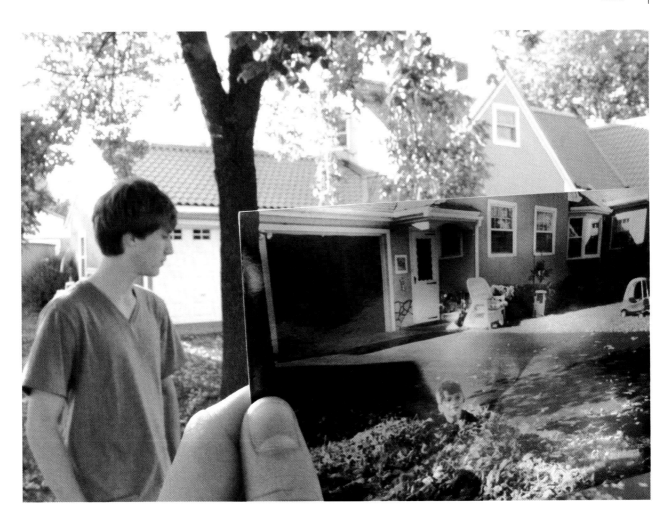

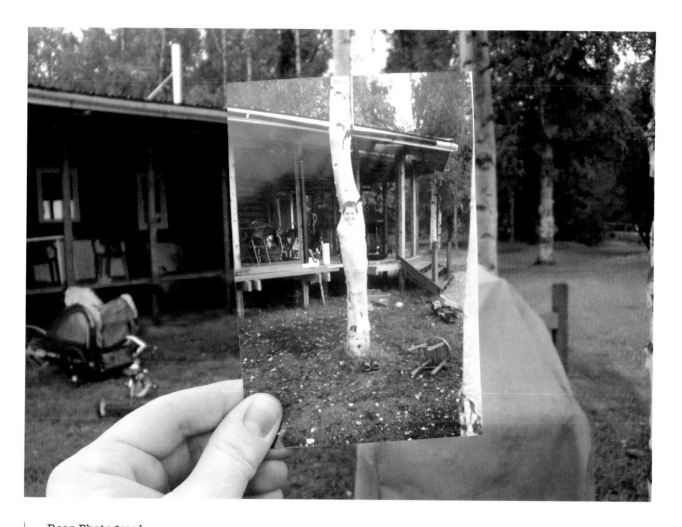

Dear Photograph,
Remember when we decided to see if shrink-wrap would hold my brother Joe
to a tree? Oh, we laughed so much! Thanks for the great memory.
Annie

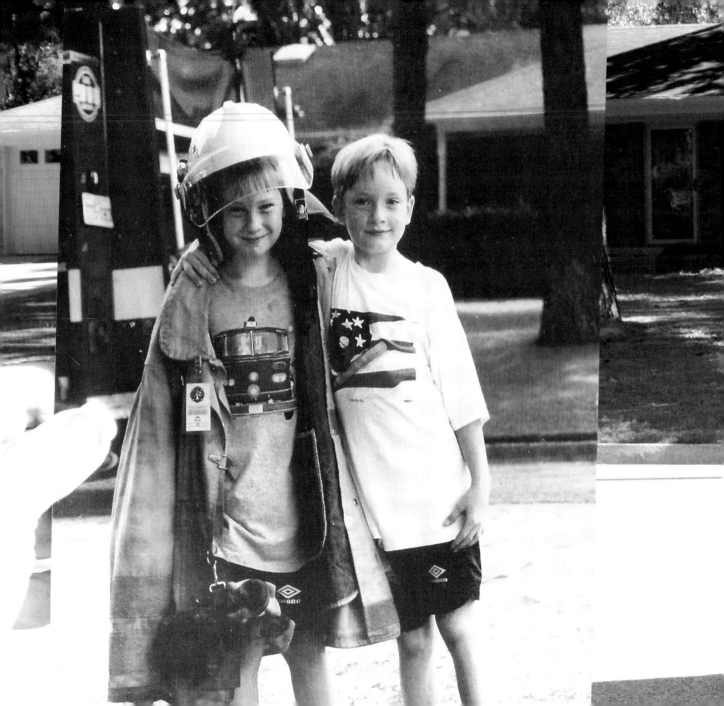

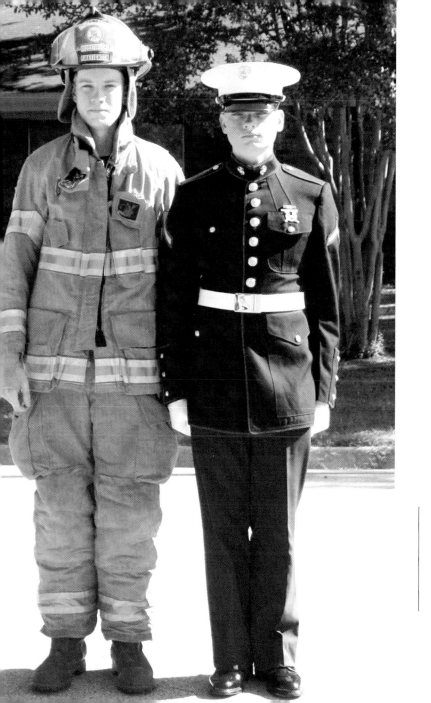

Dear Photograph,
I'm so proud my boys' childhood dreams were made of bravery, honor, and valor. Fifteen years later, dreams really do come true.
Nancy

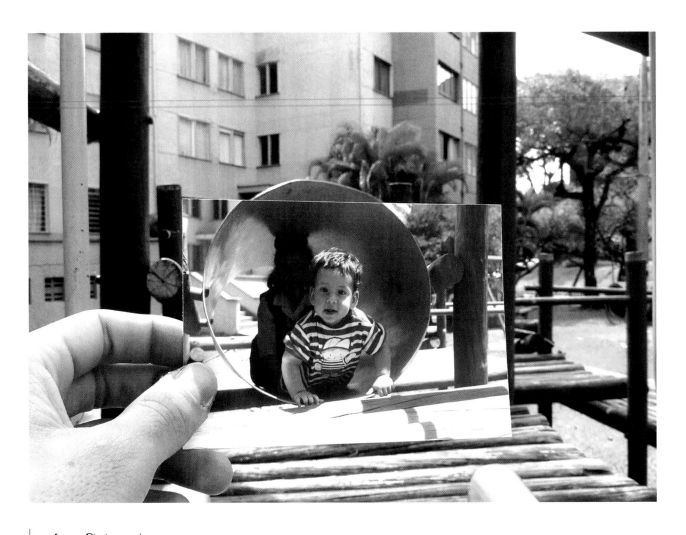

Dear Photograph,
I wish I could climb through all life's troubles so easily.
Alejandro

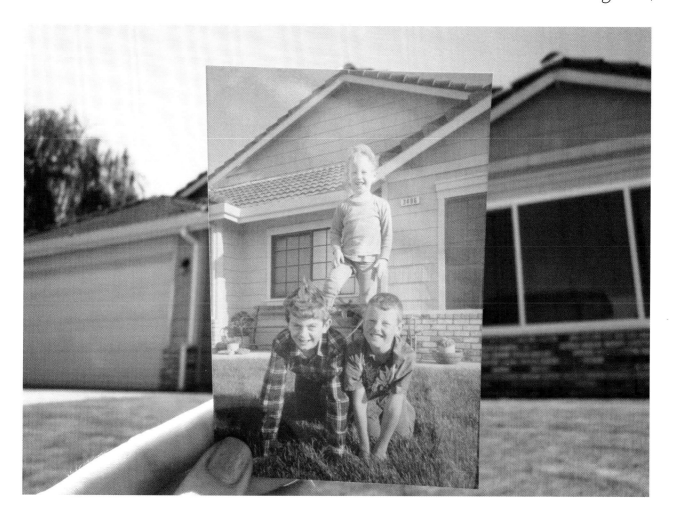

171

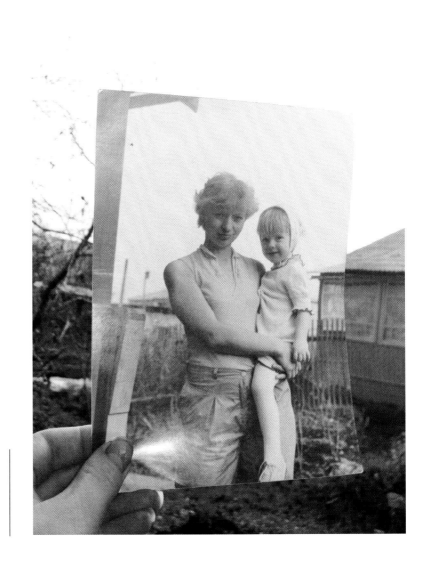

Dear Photograph,
Long ago my mom picked me
up and held me close, and yet it
seems like yesterday.
Love, Oksana

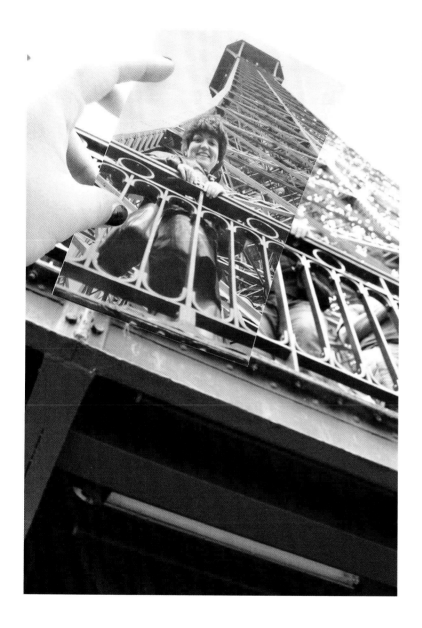

Dear Photograph,
Je t'aime, Paris, but I love my
mother more. After fifteen years
she finally brought me along!
Leah

Dear Photograph,
Now I know where my son got his swag. I wish you were here to see how well he's turned out. I know you'd be so proud. I miss you every day, Dad.
Love, Bev

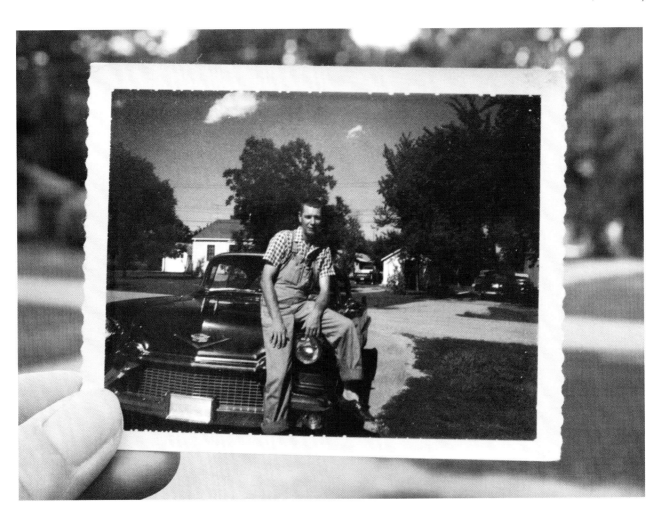

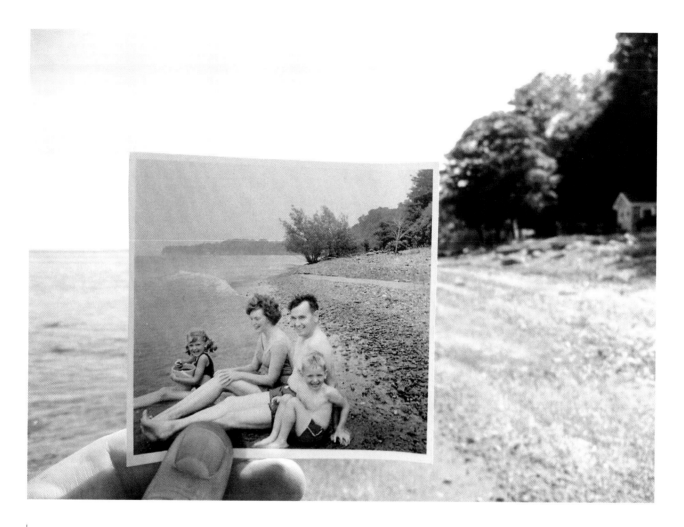

Dear Photograph,
Those were the days when we would all get our feet wet. It's what matters most.
Mark

Dear Photograph,
Being the only boy cousin among
girls couldn't have been easy.
Anna

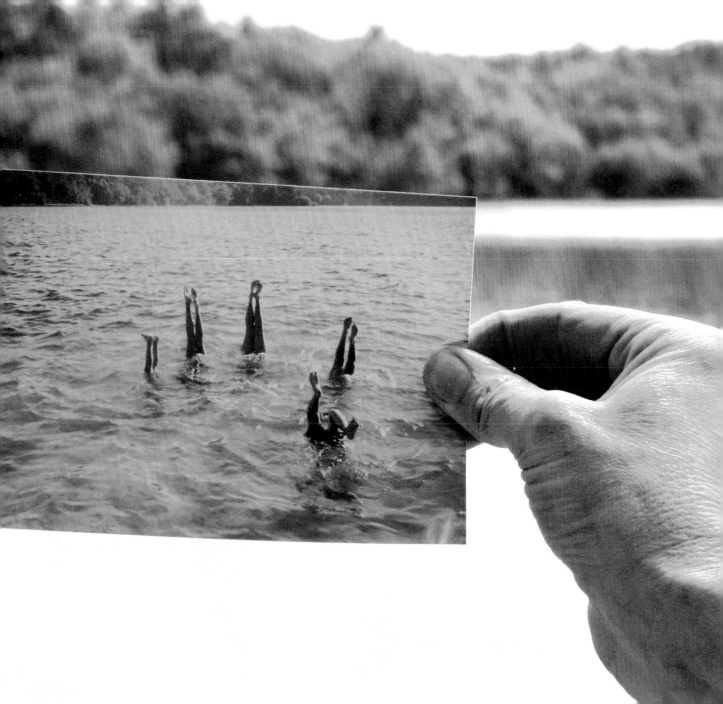

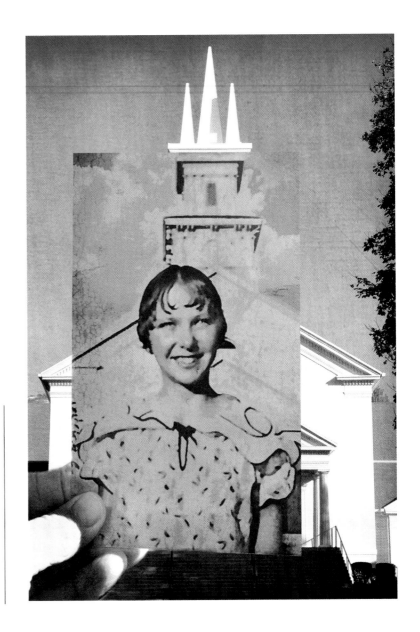

Dear Photograph,
I want the world to know you, Ruth, because you made a difference in my dad's life. He missed you greatly when you died at age nineteen. Life wasn't easy, and yet you gave my dad many fond memories, like of going on trips to the zoo and to art classes. I know you're an angel now, because I believe you were one here on earth. I wish I could've known you.
Clydene

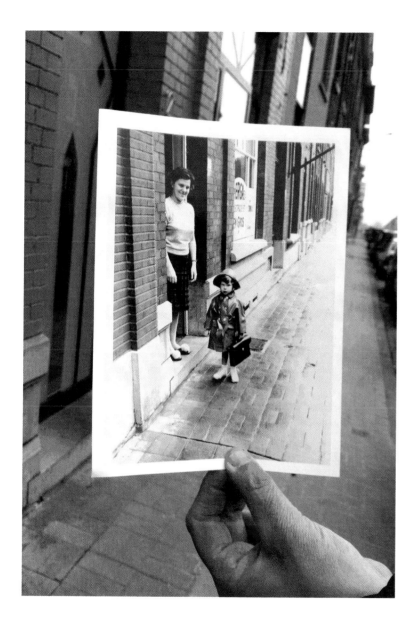

Dear Photograph,
Mother didn't want me to see her cry, so she hugged me and bravely waved good-bye as my father took me to my first day of school in 1965. No wonder he'd bought me that fisherman suit several days before—he'd wanted to keep me dry from her tears . . . and mine.
Dominique

Dear Photograph,
It's been fifty years since I wore that snowsuit, and so much has changed.
Yet in many ways, it feels like so little has. Just the way it should.
Billy

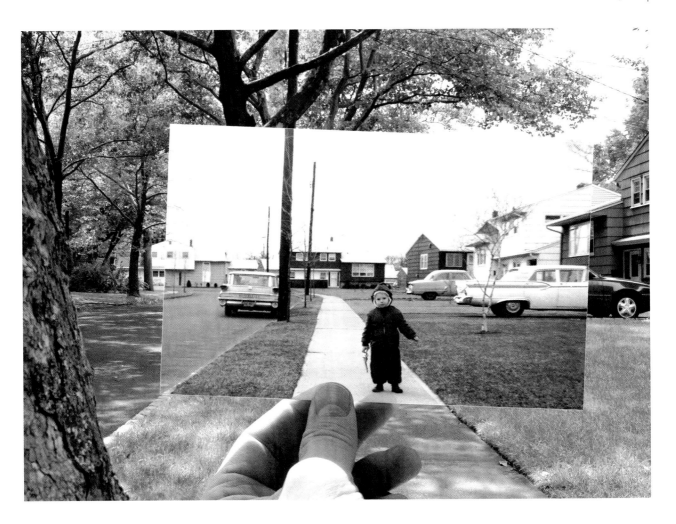

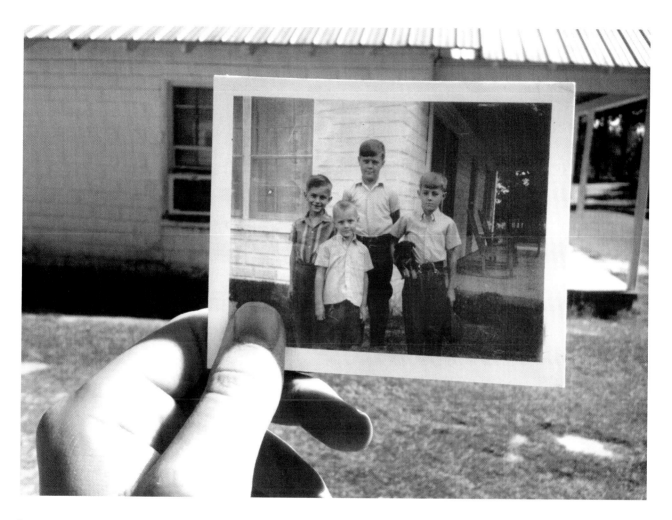

Dear Photograph,
Dad and his brothers may have cleaned up real good,
but if those walls could talk . . .
Benjamin

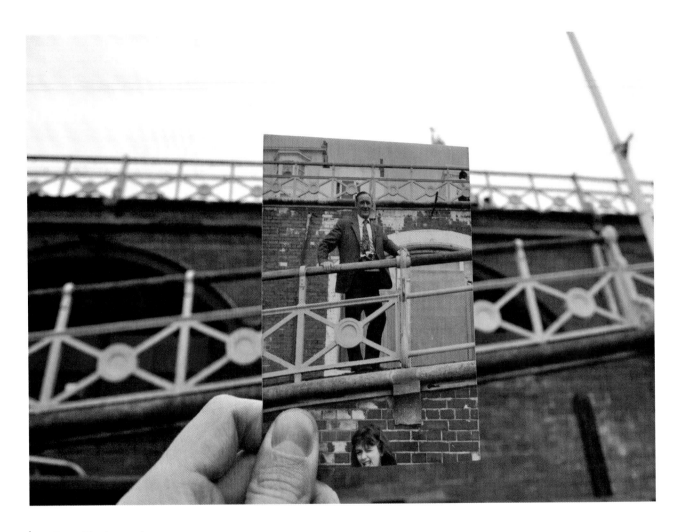

Dear Photograph,
It was great to think you were back in town looking over me,
even if it was only for just the day.
Ollie

Dear Photograph,
Little did he know he would be rebuilding
this staircase one day!
Liz

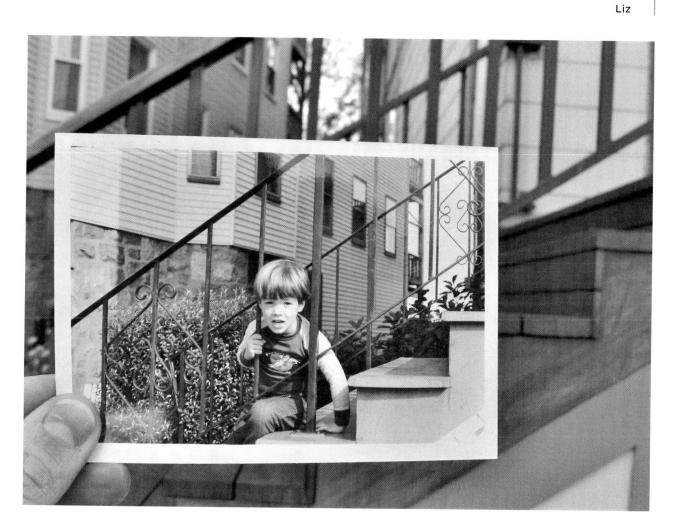

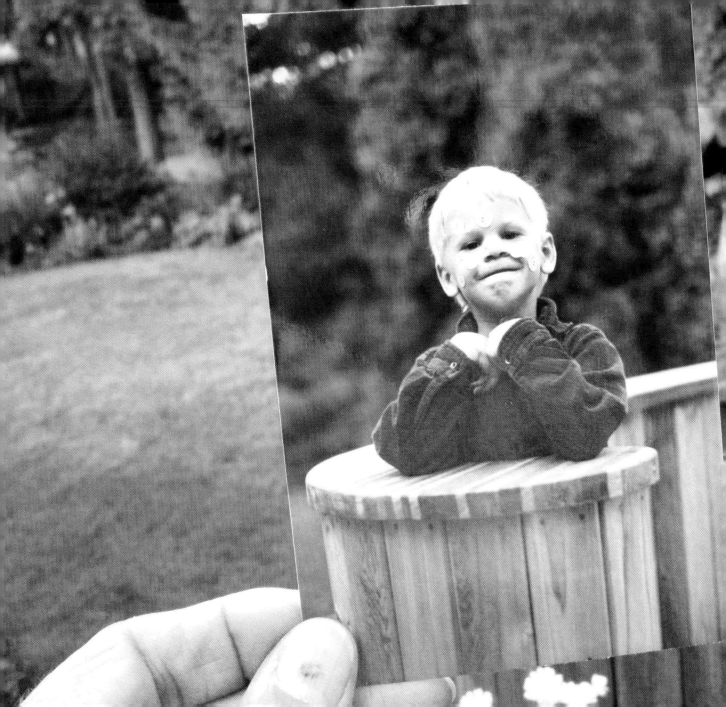

Dear Photograph,
The deck has weathered its fair share
of storms, and so have you. I'm just so
happy you kept on smiling till the sun
came out again.
Love you, Mom

185

Dear Photograph,
I wonder what advice they would give themselves now?
I'm so proud of my baby girls, all grown up.
Andy

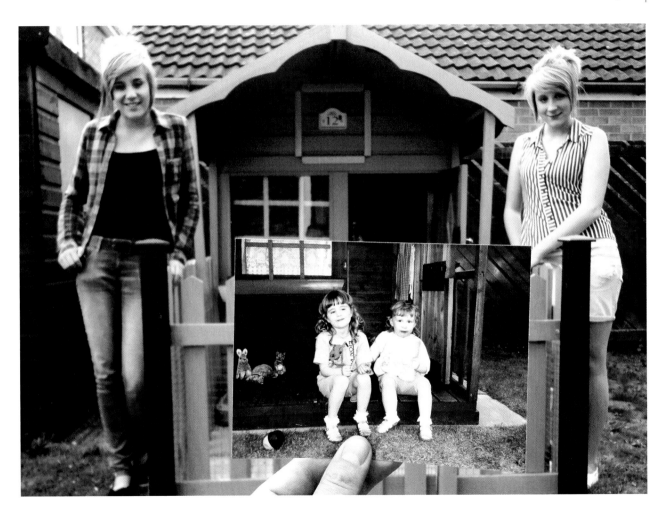

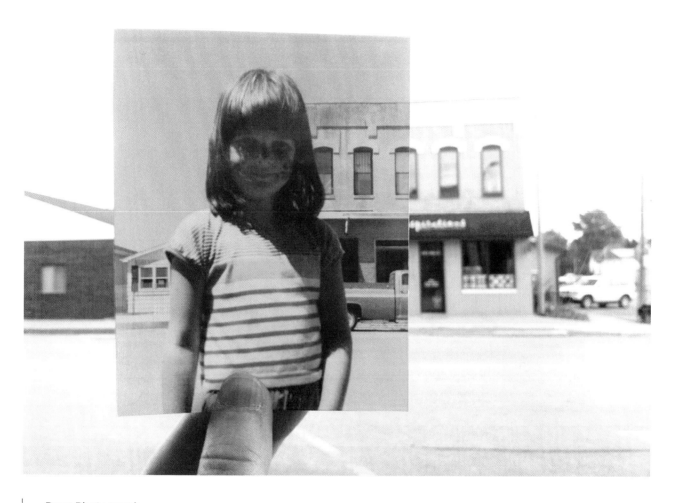

Dear Photograph,
How could my mom have known twenty-five years ago that this building
would one day make all of her dreams come true? She is my inspiration.
Love, Anna

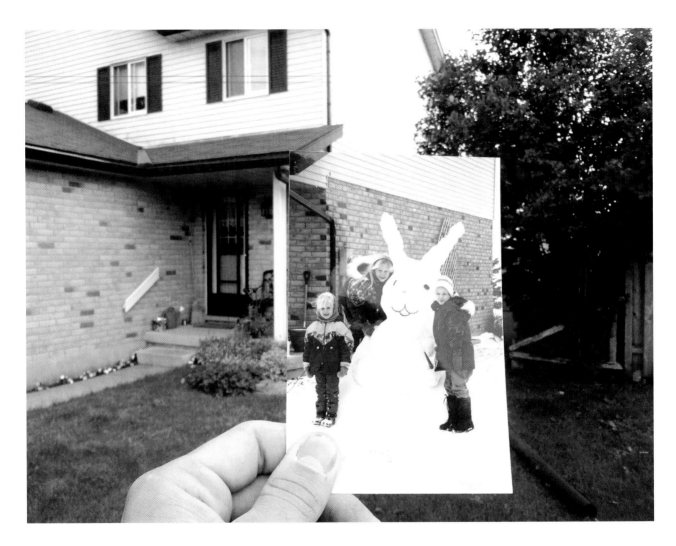

Dear Photograph,
Easter came early that year!
Jenny

Dear Photograph,
For the longest time my brother thought that babies came from airports! Now he knows this is where my life began thirty-six years ago: my adoption day was the day I got a wonderful, loving family I could call my own. Love, Brandi

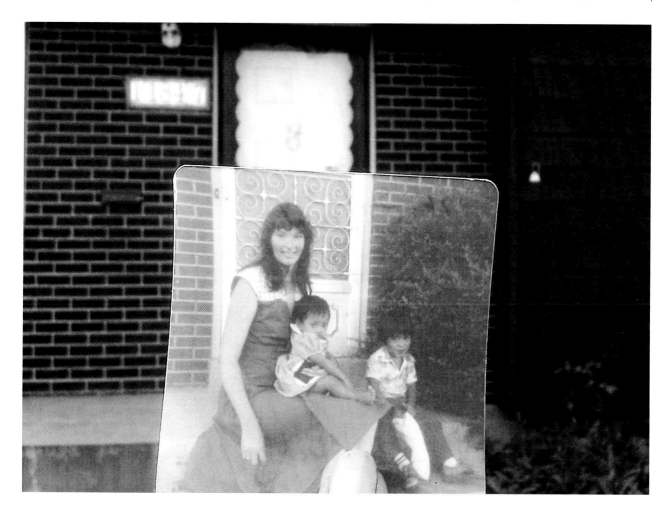

Dear Photograph,

It's the photo that reminds me of our times together and how you were—and still are—such a great dad.

It would be great to grab some bubbles and do it all again.

Love you, Justin

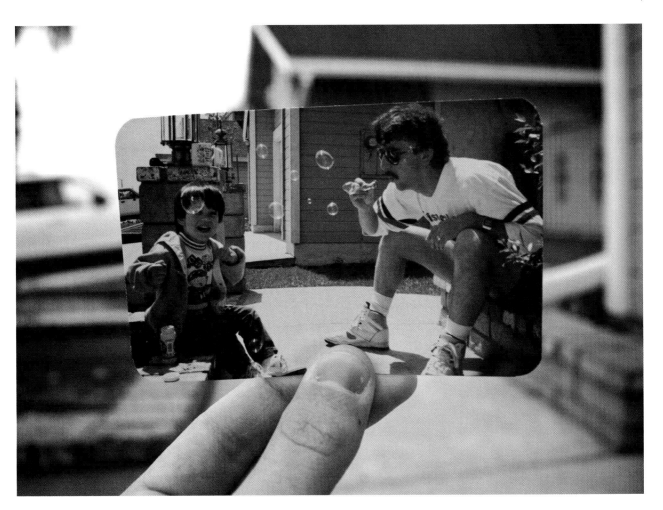

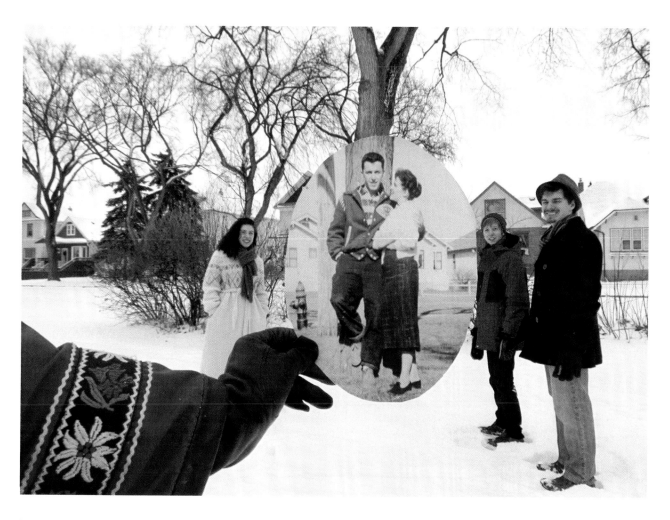

Dear Photograph,

One day after school back in 1956, Bud and Diane hung out and told a secret or two. I wonder if they were whispering about their future . . . Fifty-six years later, their family tree is still growing amazing and wonderful new branches. Kent

Dear Photograph,
The final school bell rings and suddenly,
just like that, school's out forever. No
matter how much time goes by, I will
always feel like I still belong there.
Bruna

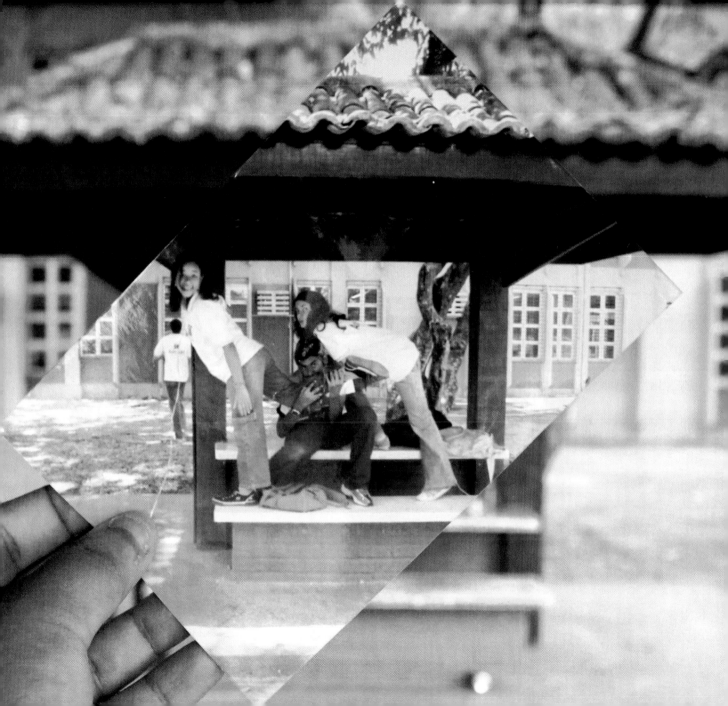

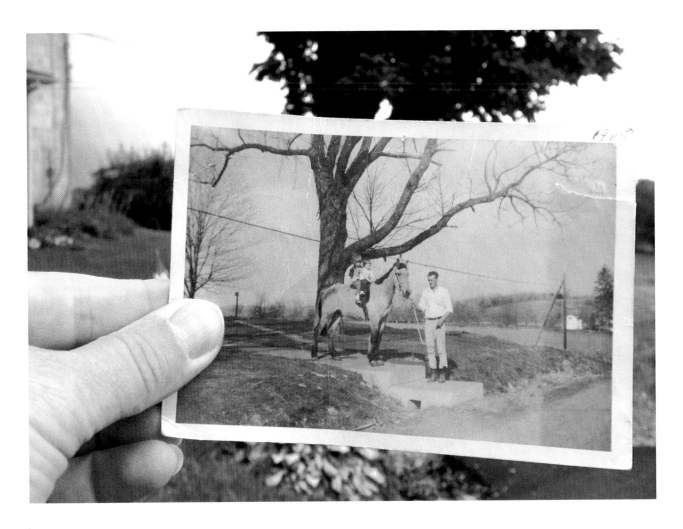

Dear Photograph,
Dad ran away from home when I was six. Please
tell him I miss him and he can come home now.
Sherry

Dear Photograph,
It's not the cottage that Dad and Grandpa built but the
memories we made there that keep us warm in the winter.
Love, Alex

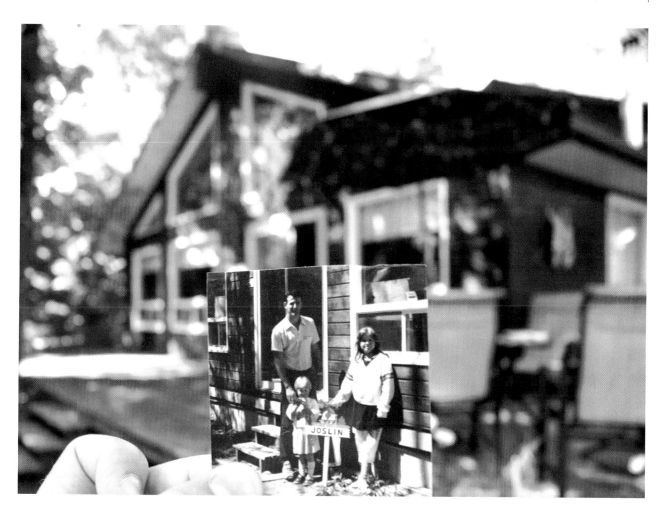

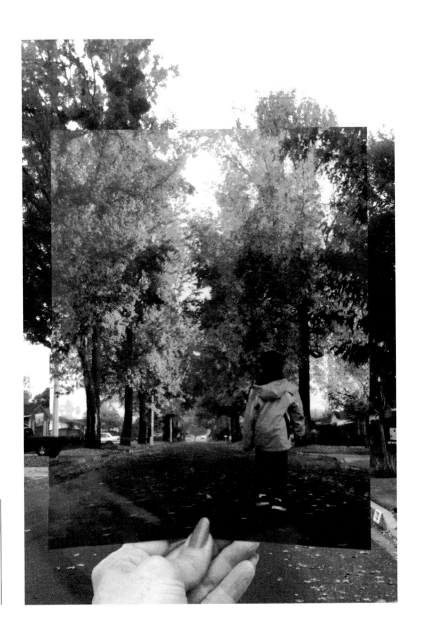

Dear Photograph,
Early morning walks together
with my little boy: those moments
will always make up the color in
my life and in my heart.
Ladyj

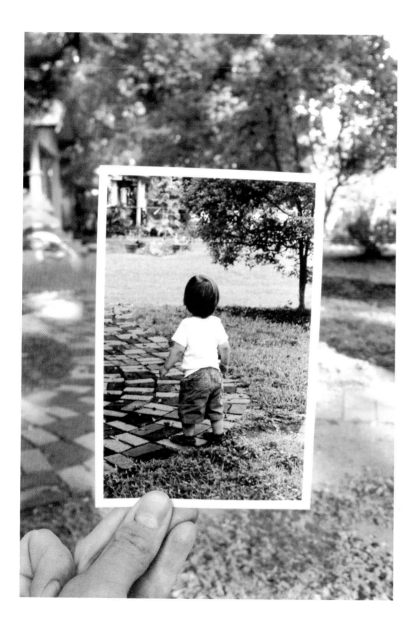

Dear Photograph,
Can you tell him to turn around?
I wanna see that cute little baby
face again.
Nicole

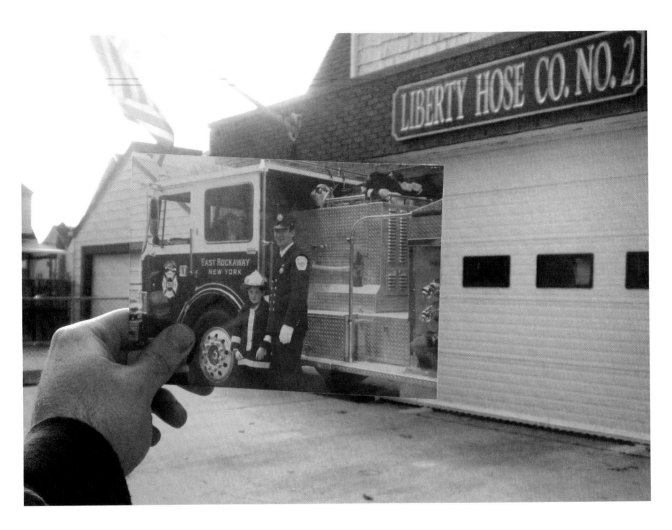

Dear Photograph,

I could not wait to grow up and become one of them. Thank you to all my brothers and sisters at the station who guided me and helped me understand that being a firefighter means so much more than just fighting fires. It truly is a rewarding way of life. Anthony

Dear Photograph,
Fifteen years ago Dad took his boy fishing.
Today I finally reeled in three!
Cole

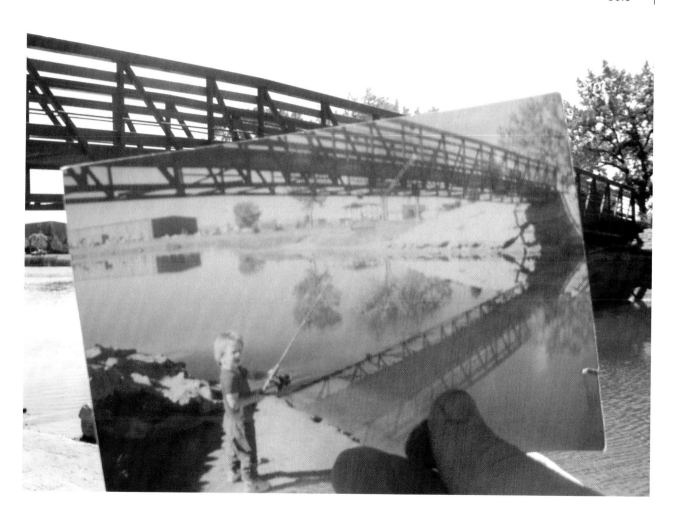

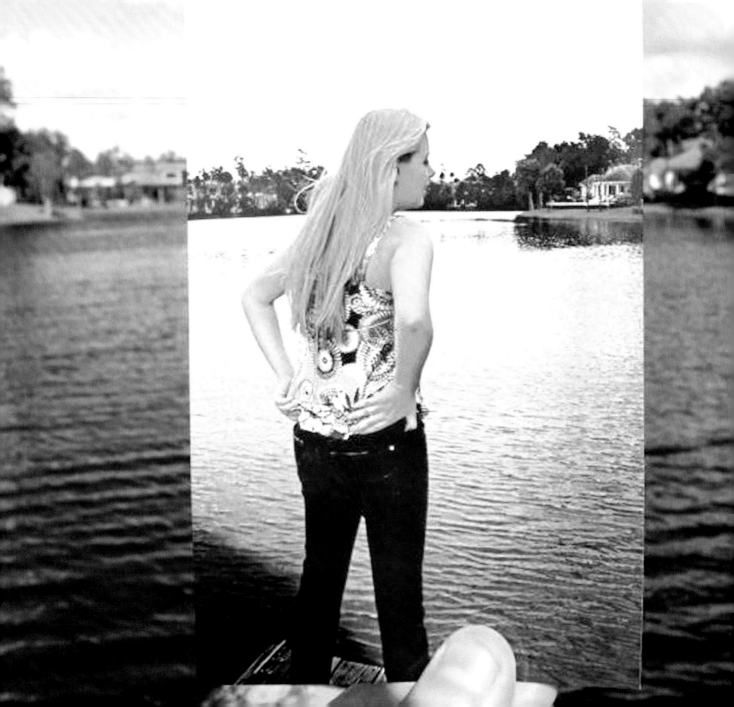

Dear Photograph,
I'll always remember my favorite
hangout spot growing up. I learned a lot
about myself on that pier.
Chandler

Dear Photograph,

Sixty years ago, Grandma Gladys stood with her parents at Forrest Lawn Cemetery. Yesterday, she was laid to rest beside them. As I held this photo, I could still hear her telling her lovely stories all over again. I will carry her beautiful spirit in my heart forever. I know she has gone back home. I'm just so glad I was loved by her. Gaby

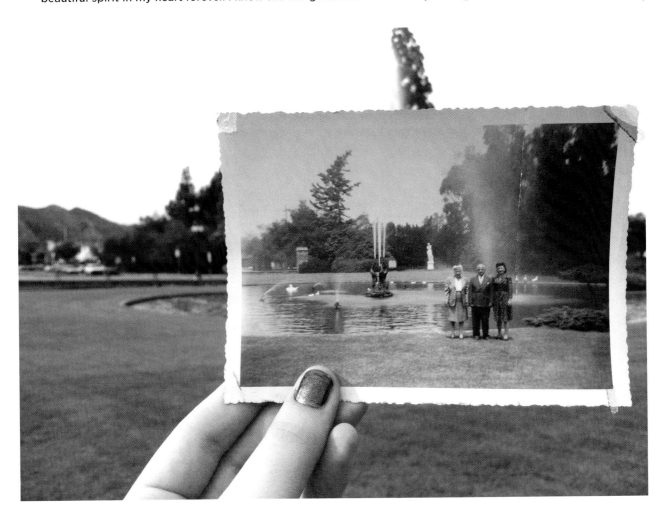

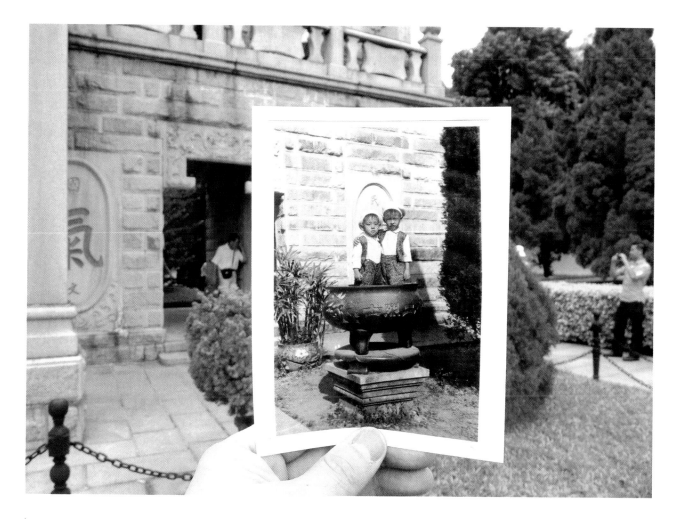

Dear Photograph,

In 1938 my dad and uncle were unaware that war was about to break out in Guangzhou, China. I'm glad they were able to be just kids even for a little while. I wish I could've been there with them.

Paul

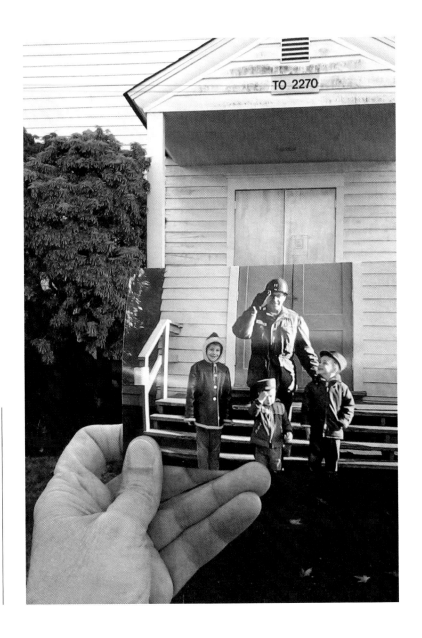

Dear Photograph,
My dad—an Army chaplain—and my loving mother laid a strong and beautiful foundation. There, standing before him, were a future Army nurse, a minister, and an Army colonel. And still his legacy continues: six decades of unbroken service in our family, all following in his footsteps. Dad would be so proud; I know I am.
Love, Rachel

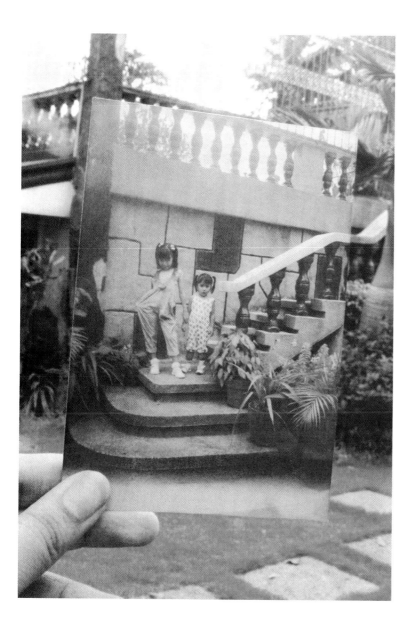

Dear Photograph,
My sister and I loved to make a grand entrance! Life was always fun when she was around.
Love, Risa

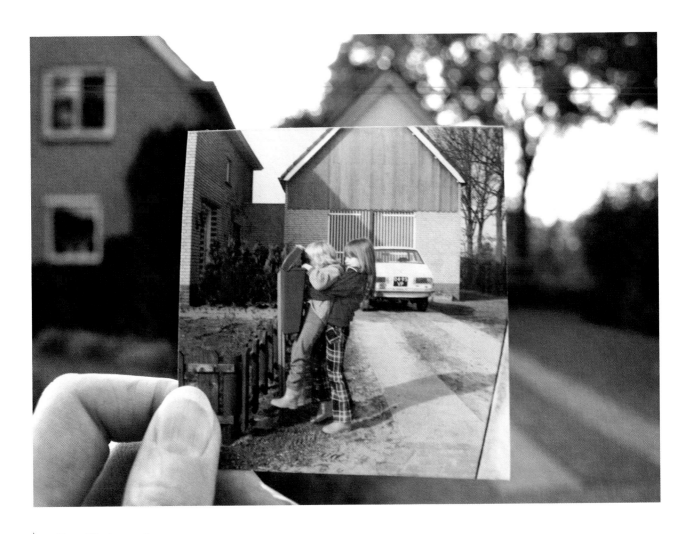

Dear Photograph,
My little sister used to need a lift here and there.
Nowadays, we lift each other up in every way.
Anja

Dear Photograph,
It's not about winning the race—
it's all about the ride.
Chrissy

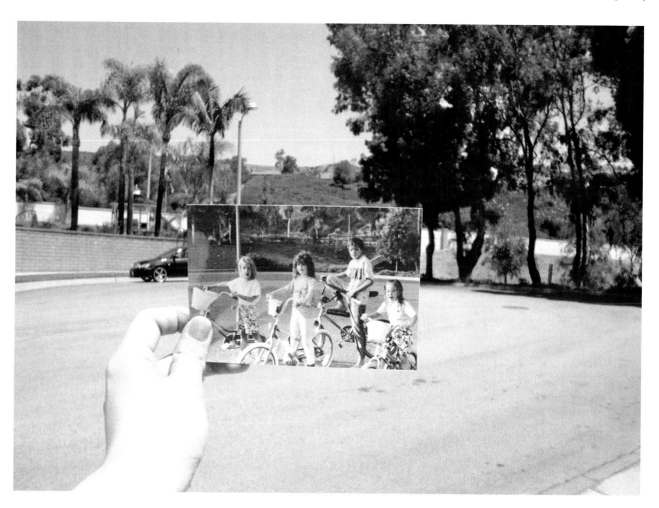

Dear Photograph,
I sure was one proud new homeowner!
Allison

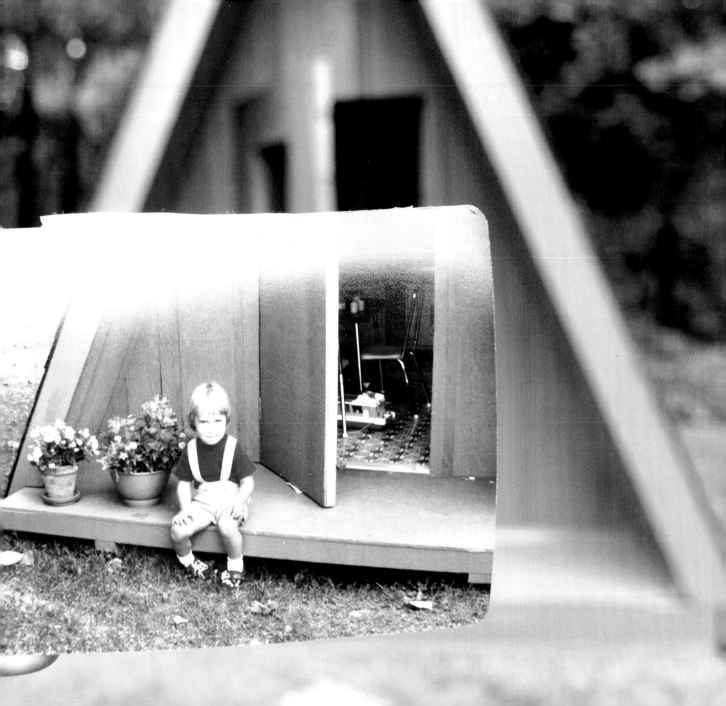

Dear Photograph,

We took the ferry to see the Statue of Liberty and missed visiting the Twin Towers. The next day will be forever etched in our hearts—we drove further and further away, watching the skies unfold with so much heartache. Freedom . . . That word has never meant so much to us. Love to the families, Stephanie

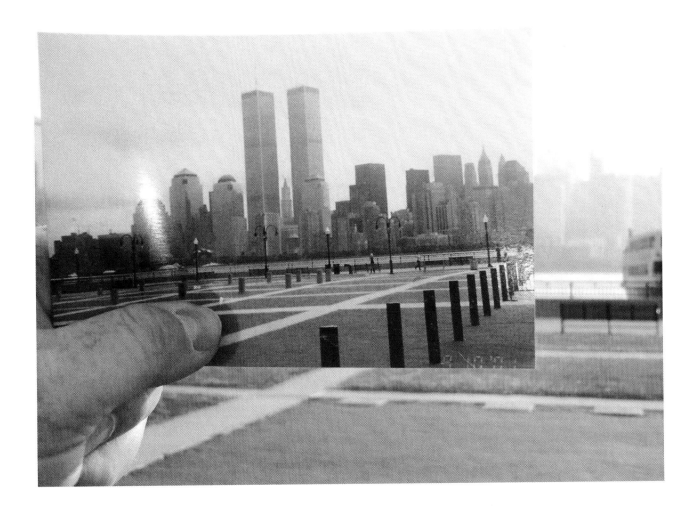

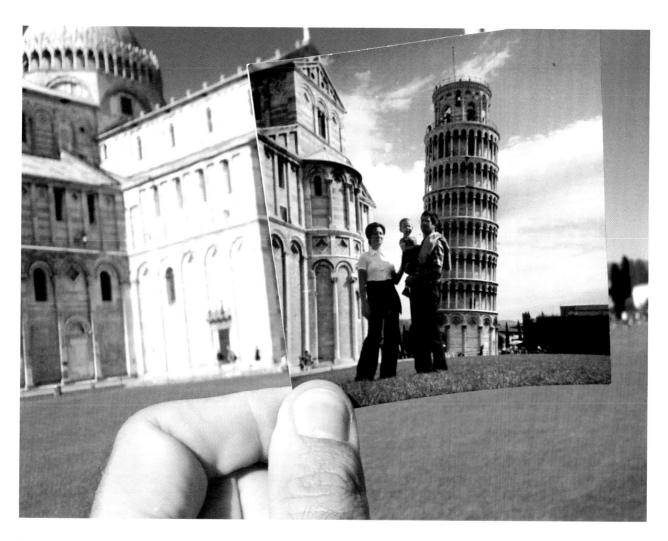

Dear Photograph,
I'll always have my parents to lean on.
Matteo

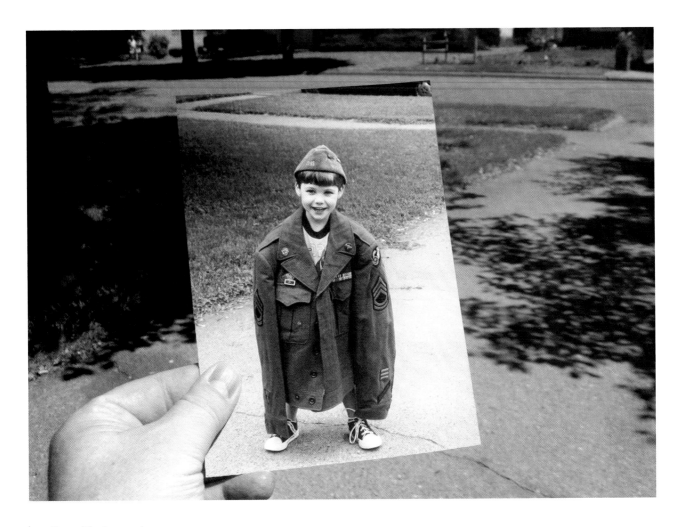

Dear Photograph,
I always knew Grandpa's jacket would
be hard to fill.
Greg

Dear Photograph,
I can still feel the warmth from Grandma's wood stove and all the happiness that radiated throughout her house. It has been long abandoned and the stove is no longer lit, yet I will never leave the happiness behind.
Love, Dawn

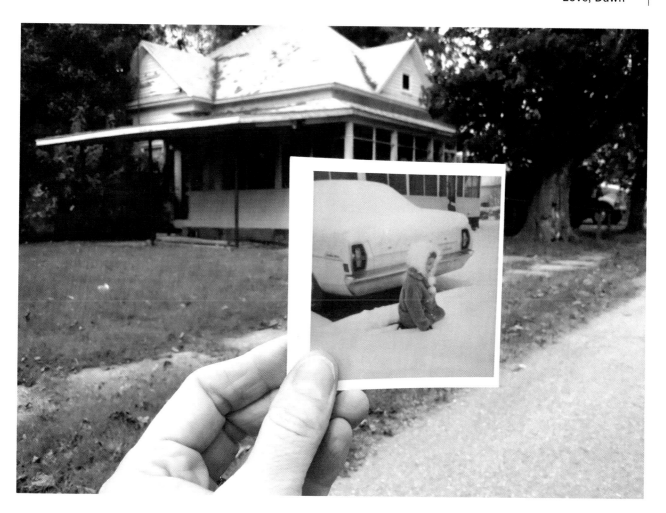

Dear Photograph,
Mom and Dad may own your house now, but I still feel you there when I bring my family home for Thanksgiving. All the years I spent running into your arms and into your house, which overflowed with the smells of the season, fill me up with such warm memories. Now I watch my sons embrace their grandmother the same way. Andrew

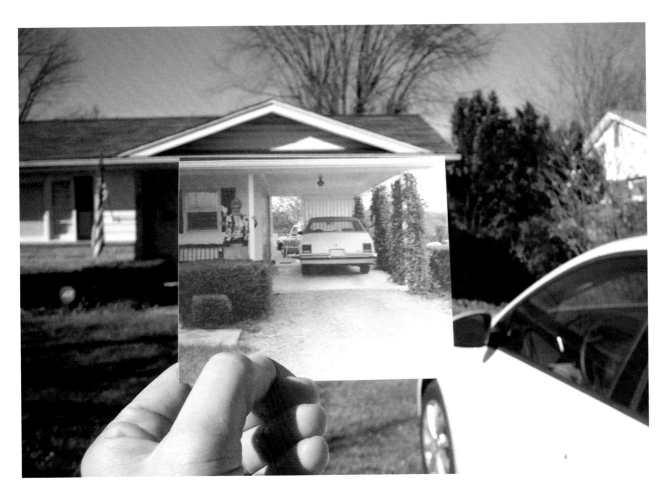

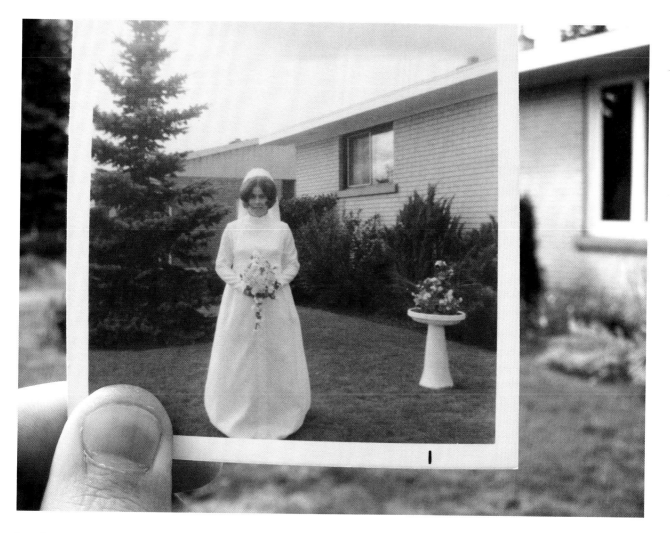

Dear Photograph,
My dad became the luckiest man on earth that day.
Love, C&C

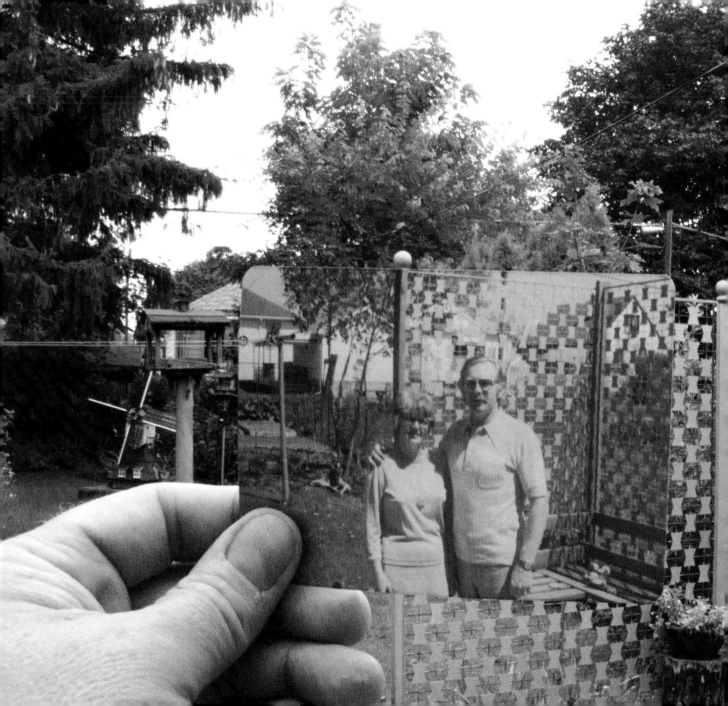

Dear Photograph,
When I took this of you back in the seventies, I didn't realize how good life truly was. I miss you, Mum.
David

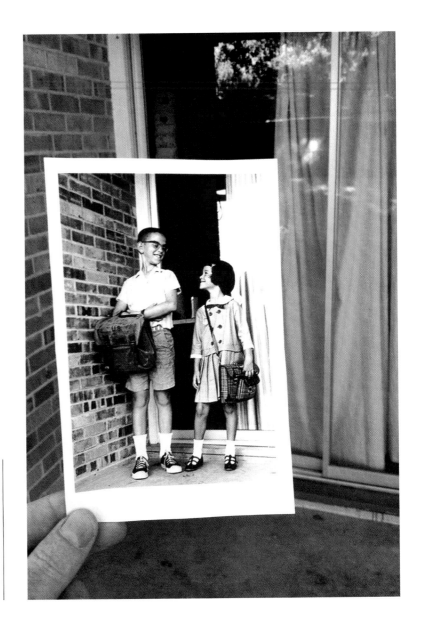

Dear Photograph,
I remember squirming every year when Dad would stop my sister and me to take that corny first-day-of-school picture. I realize now that father knows best, as I share this photo with my grandchildren.
Tom

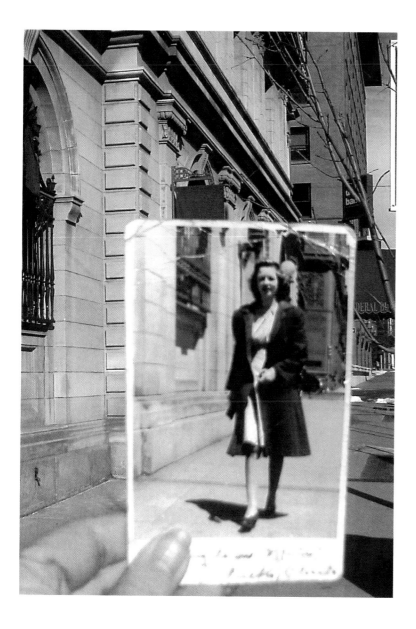

Dear Photograph,
If I could turn the corner in 1942 and walk right into my mother, I'd ask her, "May I walk beside you one more time?"
Love, Michelle

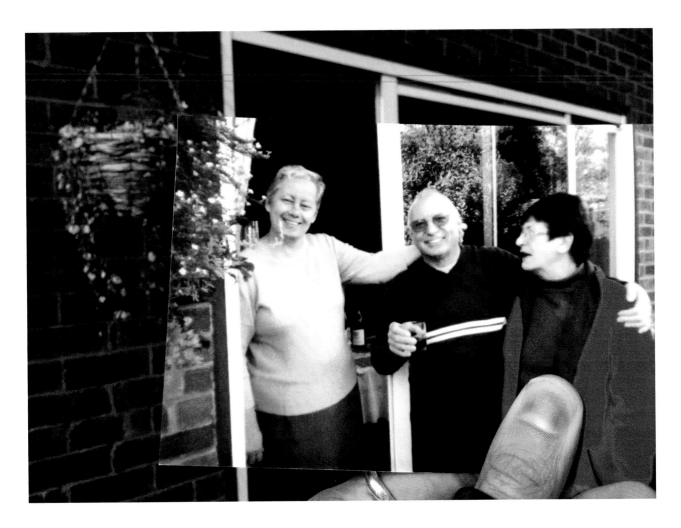

Dear Photograph,
It's your lovely smile, Mum, and your kind-hearted ways that I'll carry with me everywhere and always. That is something Alzheimer's can never take away.
Love, your son, Robin

Dear Photograph,
I loved coming around the corner and finding him up to his little elbows
helping out his mommy. That was an instant smile-on-my-face moment.
Mel

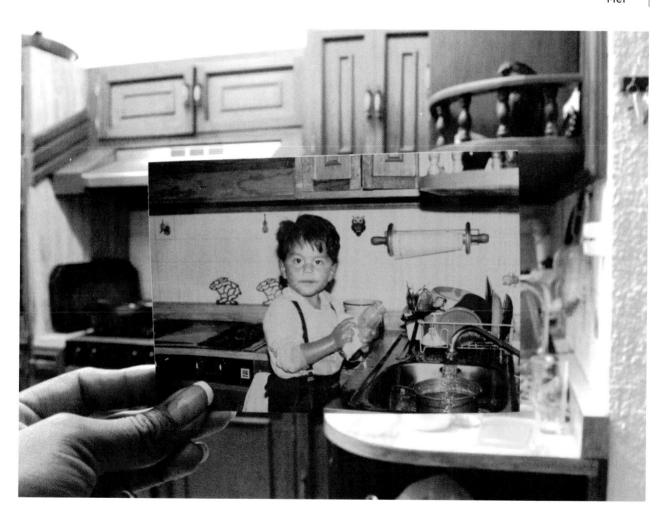

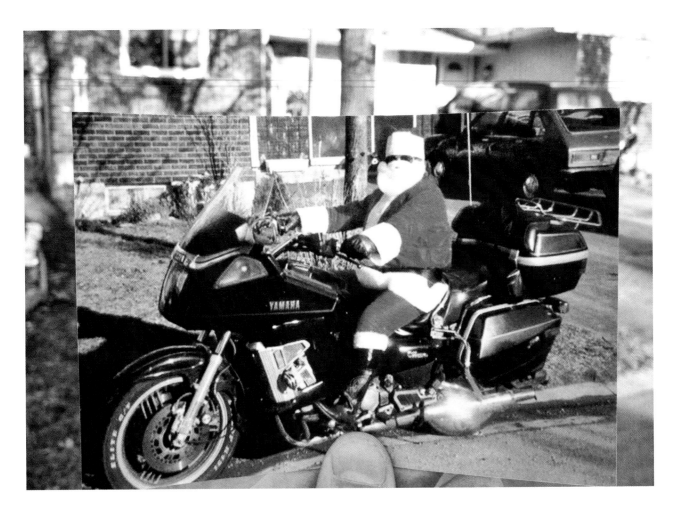

Dear Photograph,

Over twenty years ago my father rode his bike around town at Christmas and made so many people happy. This Christmas, I hopped on my Harley and continued his tradition—spreading loads of Christmas cheer, handing out Tim Hortons gift cards, and making people smile! Merry Christmas, Dad. I'm so proud to follow in your footsteps. Jesse

Dear Photograph,
Growing up the lone partridge in a pear tree, with three hens a-clucking, I rarely had a silent night. Even when I'm all tangled up in their drama, I can't wait for the holidays so we can be together and strung up once more. Zach

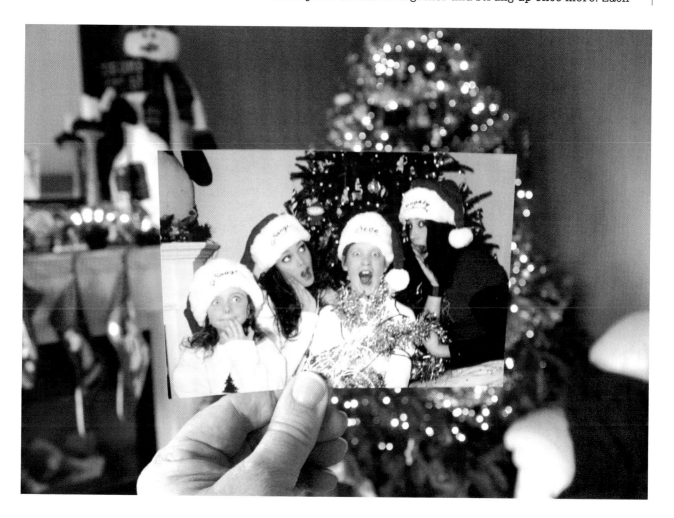

Dear Photograph,
Why is it that summer used to seem to
last for years? Now it barely touches
the ground and it's gone . . .
Matthew

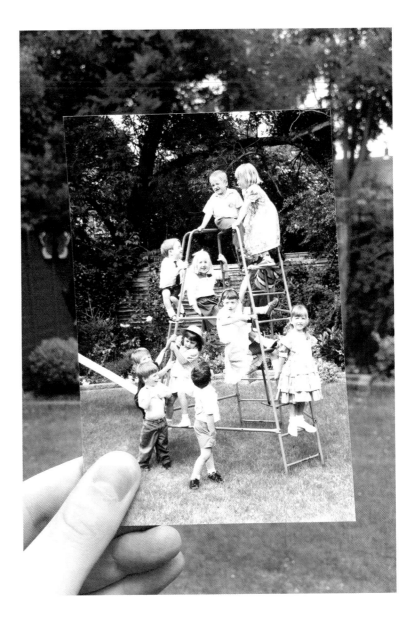

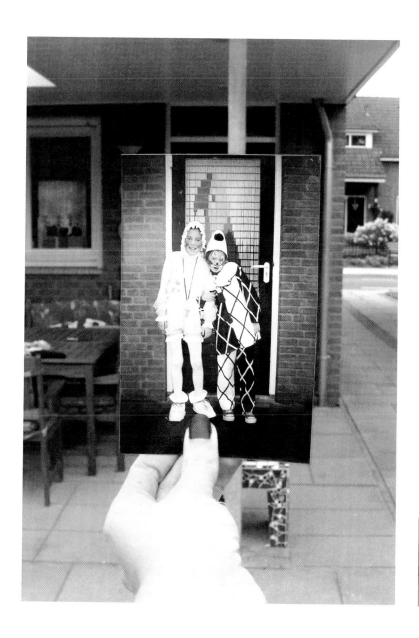

Dear Photograph,
We were inseparable for twenty-six years, until cancer came her way. Can you please give me my sister back?
Loesje

Dear Photograph,
I lived in this house for almost my whole life. Now I have come back to live in it once more, only this time
I am bringing my own family to live and love here. It's amazing how some things never change!
Victor

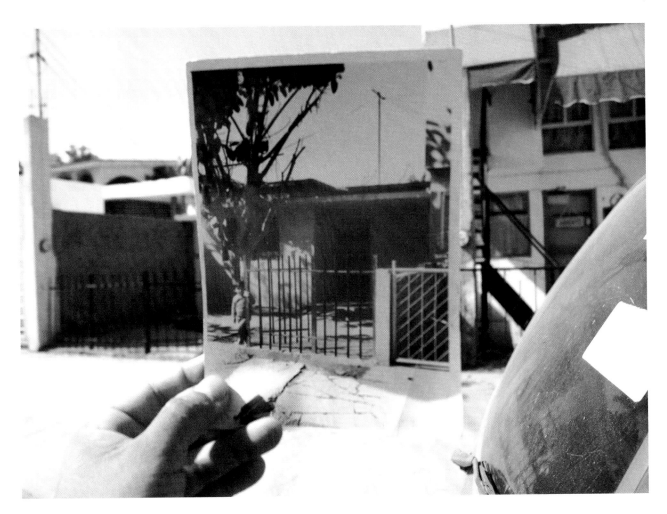

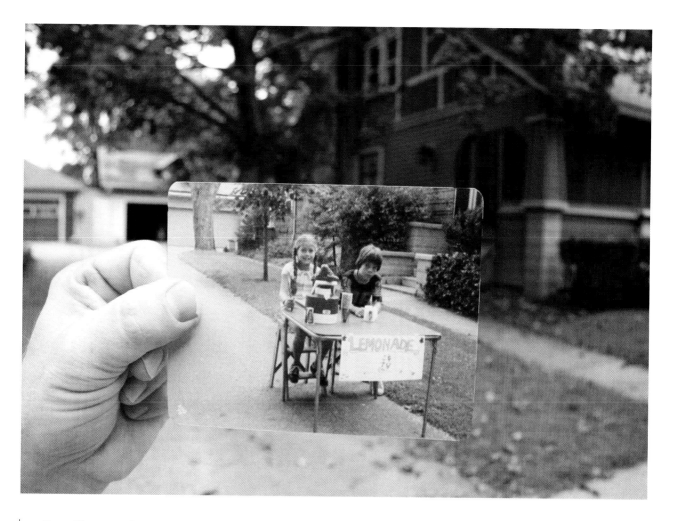

Dear Photograph,

Our lemonade wasn't a very big hit that day. Maybe we should have used real lemons instead of all that granulated stuff.

Tyge

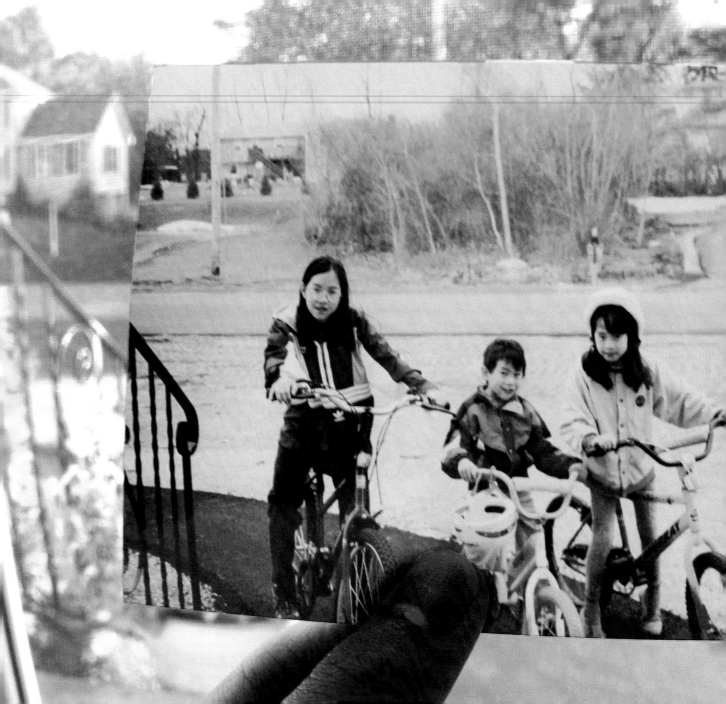

Dear Photograph,
My first bike was a pink hand-me-down,
and I'd never been so happy in my life!
Alex

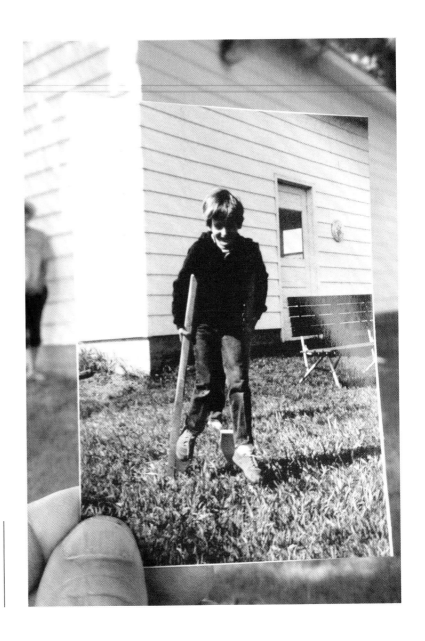

Dear Photograph,
Mom was so proud of my homemade
stilts a quarter century ago. I loved
walking tall that day.
Mark

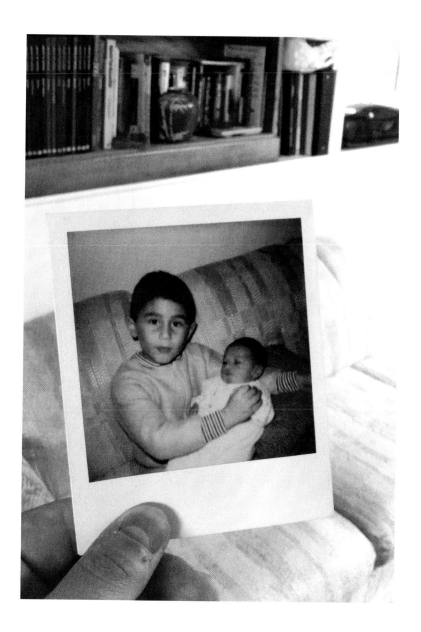

Dear Photograph,
Every friendship has a beginning;
this is ours.
Lee and Sarah

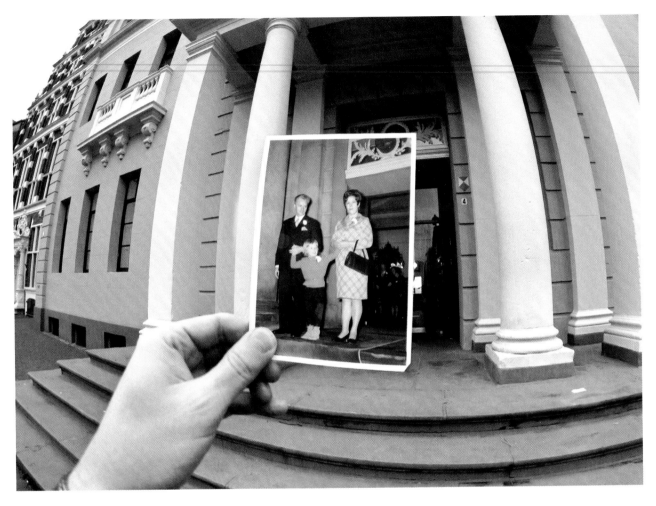

Dear Photograph,
Take my hand one more time, dear Mother and Father,
and I will hold on tight, hoping to never let you go.
Peter

Dear Photograph,

It takes a great architect to create something strong and everlasting, and when I look back at our first family road trip to see the Golden Gate Bridge, I realize that our mom is the greatest architect ever. She taught us the importance of family and of sticking together no matter what. We built many memories that summer in the '70s, and all without iPods or cell phones—just us. That's golden and so is Mom . . . She's seventy-five now. Love, Colleen

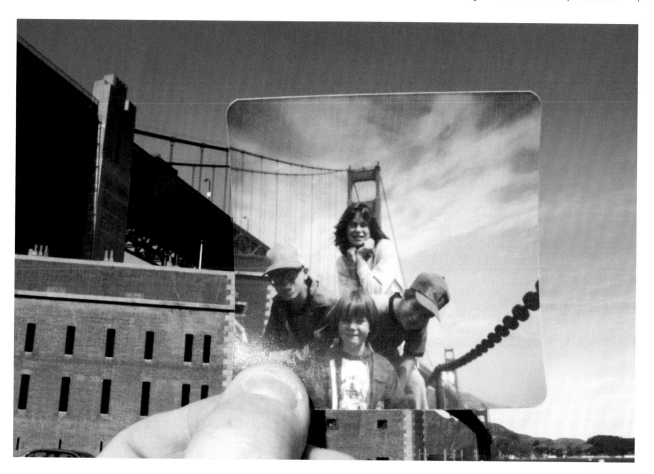

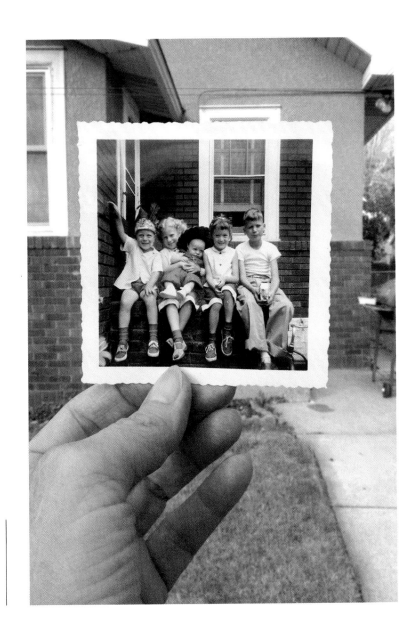

Dear Photograph,
My cousins and I were a ragtag
group back then . . . but we sure
had fun and we still do!
Barb

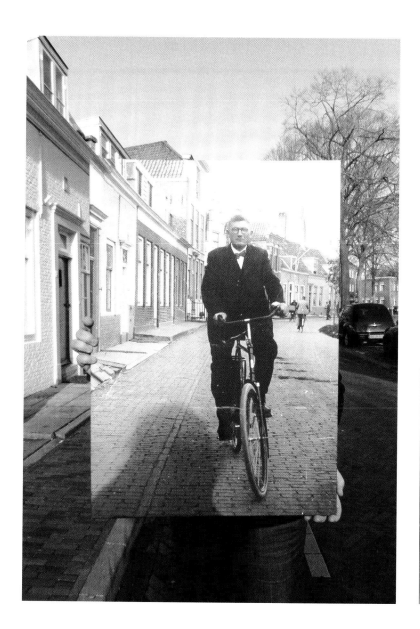

Dear Photograph,
My great-great-grandfather rode through Middelburg, Netherlands, in 1935 and was known to all as the town butcher. Today when the elderly ladies see this photo hanging on the lunchroom wall, they talk of visiting his store as little girls and of how he would give them a piece of ham. Perhaps if I went back in time and walked up to his counter, he would give me a little piece of ham . . . and a little advice.
Helen

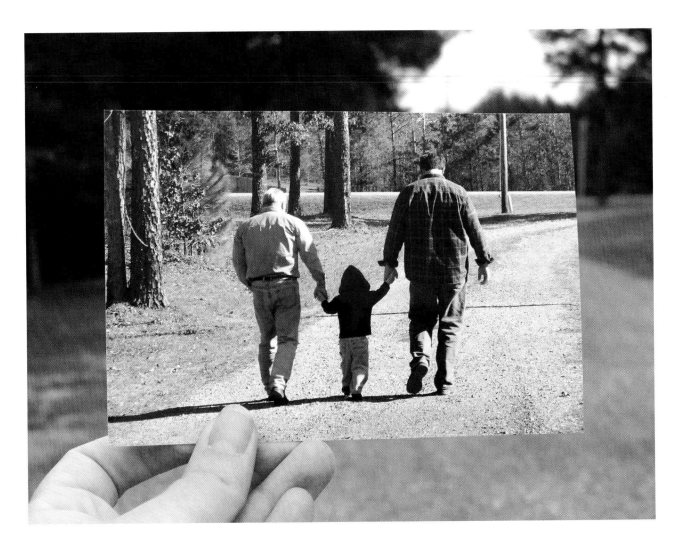

Dear Photograph,
I hope he never forgets these walks.
Tracy

Dear Photograph,
For one brief moment, this murky little duck pond
became the most beautiful place on earth.
Greg

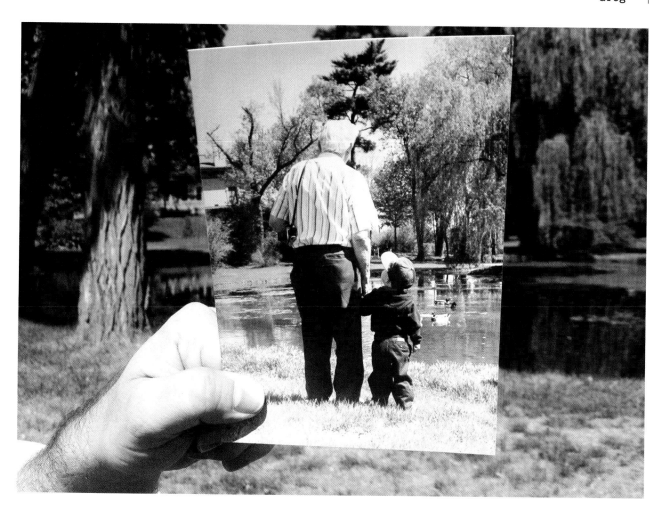

237

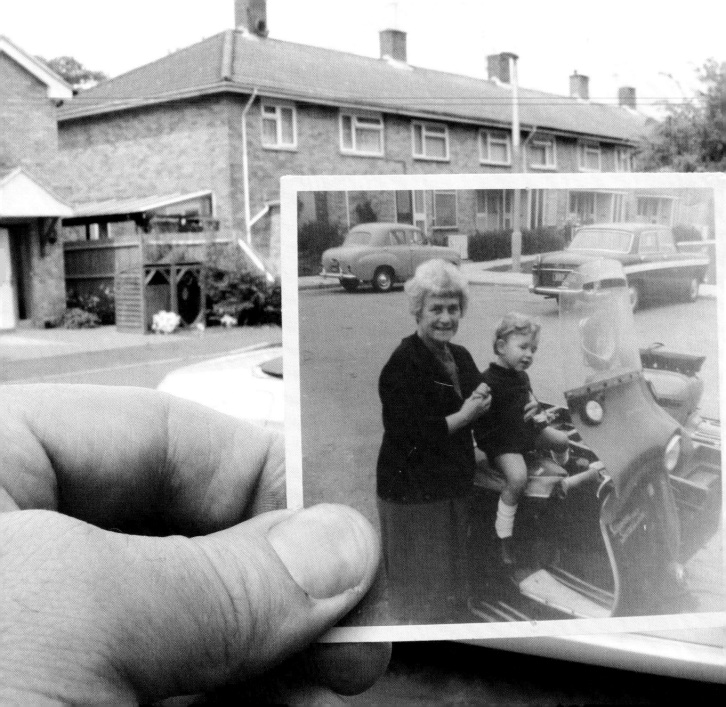

Dear Photograph,
Nana always cared for us.
Jeffrey

Dear Photograph,
Sometimes I wish I could go back in time and return to my carefree days of childhood.
Being grown up isn't as much fun as I thought it would be . . .
Annette

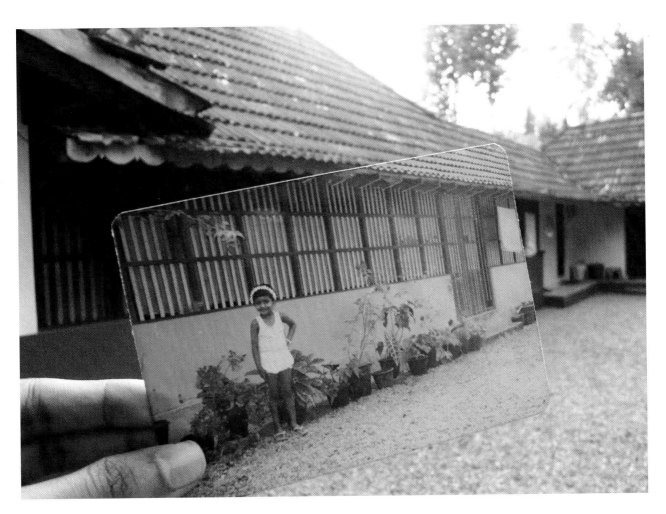

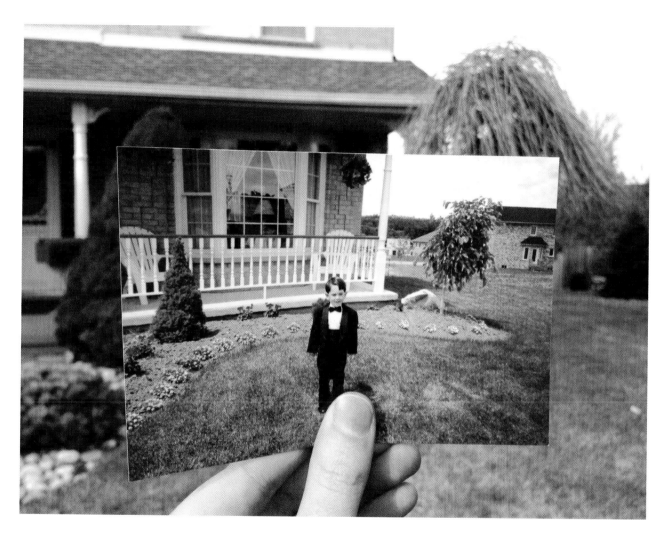

Dear Photograph,
I looked good in a tux.
Taylor Jones

ACKNOWLEDGMENTS

Mom and Dad, thanks for supporting everything I do and for always looking out for me. The path you've led me on has made this book possible. To my brothers: Landon, thanks for posing for that first Dear Photograph on your third birthday; Keaton, keep swinging that golf club, kid, and thanks for showing me how to have #swag. Papa and Grandma, you're amazing people, and I look up to both of you so much. Uncle Kirk, Vanessa, and Reny, and Uncle Don, Denise, Jessie, Colt, and Cam, thanks for being supportive family members. Papa Jones, Nana, and Nannie: thanks for looking out for me from up above. My bros, Josh, Justin, Sawyer, Matt, Mark, Hardy, Chard, Bam, Jono, and Cam: you guys are the coolest dudes in the world. Shan, Moore, Lindsay, Seif, Taylor, Alex, Nat, Andrea, Rob at Skate4Cancer, KaitKub, Mel, Jenny and Gary Kait, Eric, the Blasmans, the Iannis, Ashley Newbrough and family, and Richwood Court. ABC World News: Christine, Bradley, and Diane Sawyer. Quarry Integrated Communications. Everyone at BlackBerry for their continued support. Carbon Computing for their love and friendship. Communitech and Kitchener-Waterloo Oktoberfest for helping me along the way. My teachers Joe, Deb, and Mrs. Weidinger. Frank Warren from PostSecret, Neil Pasricha from *The Book of Awesome*, and Amber Mac. Steve Jobs for his inspiration. ArthurSousa.com for his amazing web design skills. Alyssa Reuben at Paradigm for originally reaching out to me. Andrew and Greg at Paradigm. Cassie Jones and Kate Cassaday at HarperCollins for believing in *Dear Photograph* the book. Lisa Bettencourt for her design, and Kelly Hope for the finishing touches. Twitter friends: I wish I could name every single one of you. Instead . . . thank you so much, @ _____ ! Facebook friends: sorry for all the status updates, but thanks for supporting! Every single person who submitted a photo to this project: thank you so much. I couldn't have done it without you. Karen Newbrough, my manager, you're the thumb in the Dear Photograph logo. You've been my backbone from the beginning and the most honest, upfront, and hardworking person I've ever had the chance to work with. Let the fun begin!

PHOTO CREDITS

Page 7, Elizabeth Charlotte Tafaro; 10, G. Ryan Buschmeyer & Greg Buschmeyer; 12–13, Jade Healy; 14, Ben Pirotte; 15, J Hermann; 16, Holly Schnider; 17, John Shafer; 20 top, Nicole Croy; 20 bottom, Deanna Schmidt; 21 top, Shaunie C.; 21 bottom, Justin Godelie; 22, Pamela Dusbabek; 23, Laura Zimmermann Kokesh; 24, Alex Ambuehl; 25, Fer Meccia; 26, Angela Wu; 27, George Woodhams; 28–29, Linda McDonald via Kim Emond; 30, Sandra Joyce; 31, Darin White; 32, Barb Edmonds; 33, David L. Glazer; 34, Kyler Zeleny; 35, Louise, Jean-Jacques & Yves Richard; 36, Dana Gelinger; 37, Luis Picolo; 38–39, McKenzie D.; 40, Michelle Nagle; 41, Malwa Kaszubska; 42, John W. Golterman; 44, Beth Burkhalter; 45, Pat Handley; 46, A. L. U.; 47, Adam Fraser; 48–49, Mark Albain; 50, Alex Thornton; 51, Sophia Dinh; 53, Julie Patricia Horne; 54, Rachel Cleverley; 55, Alanna Mallon; 56–57, B.J. Best; 58, Jennifer Miller; 59, Jacki Yovanoff; 60, Kimberlyfab; 61, Adam Robinson; 62, Marisa Simmons; 63, Jessica Joyce; 64–65, Oliver Manuel; 67, Patrick Bryant; 68, Aleksey Busygin; 69, Jeff Pitcher; 70, Amy M. Rickert; 71, John Habbinga; 72–73, Camillia Courts, inset photo by Neil Slattery; 74, Claire Harper; 75, A. Prodanou; 76, Winnie W. Fong; 77, Tamia Larson Wardle; 78, Eric O.; 79, Dario Sepulveda; 80–81, Beth Galloway; 82, Katy Ann Wilwerding; 83, Maggy O'Reilly VanOrder; 84, Edgar Toyos; 85, Louis Daniel Le; 86, Chris Peters; 87, Daniel Michael Hubbard; 88–89, Jennifer Richter; 90, Wendy Silva; 91, Jill Peters; 92, Lesley W.; 93, Jennifer Black on behalf of Jacki Yovanoff; 94, Alfredo Moreno; 95, Jean Park; 96–97, Kari Frizzle; 98, Ivan Williams; 99, Andrew Benedict; 100, Greg Robinson; 101, Carol Colborne; 102, Ursula Kohlert; 103, Danaé O'Bryan; 106, Mark Winner & Vonnie Tripodo; 107, Casie Stewart; 108, Michael Mckenzie; 109, Chloe Liz; 111, Nina LoSchiavo; 112–113, Paisley Stone; 114, Nicole Johnson; 115, Robin; 116, Onno Swagerman; 117, Susan Mastellone; 118, Anderson Sérgio de Barros; 119, Gael; 120–121, Helen Schmidtke; 122, Benjamin Hazzard; 123, Aaron Adel; 124, T.J. Freeman Jr.; 125, Eric Monrad; 126, Linda Zeman Wensel; 127, Danae Castellaw; 128–129, Kris Loewen; 130, Kenny D. Smith (www.kennysmith.org);

Author photo: Holly Schnider
www.photosbyholly.ca

TAYLOR JONES

was inspired to create Dear Photograph as he flipped through old family photos at his parents' kitchen table. The twenty-one-year-old came across one of his brother sitting at the same table and lifted it up to match the lines of the photo to what he saw in front of him, then snapped a picture of the picture. In a moment, the idea for **DearPhotograph.com** was born. Jones took a few more Dear Photographs and posted them on a website, asking people to submit their own, and in six short weeks, millions of people had visited, hundreds of photographs had been submitted, and Jones had created an Internet phenomenon that captured the world's attention. Visit him on Facebook at **facebook.com/dearphotograph** or on Twitter **@dearphotograph**.